IMAGES
of America

A SWISS COMMUNITY
IN ADAMS COUNTY

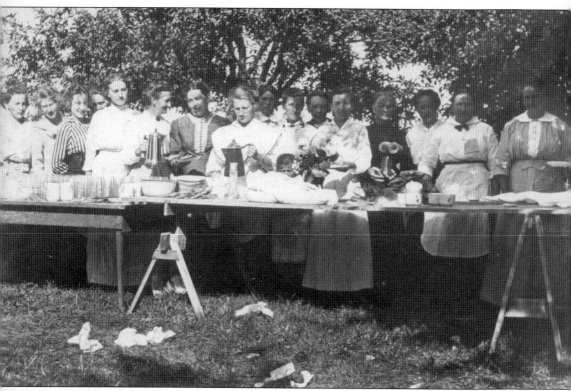

The locals loved picnics in the woods and found all sorts of occasions to have them. Two farmers, whose land was adjacent to Berne, neatly cleared their woods of underbrush and made them available to groups free of charge. C.C. "Criggey" Sprunger's facility was known as Criggey's Woods, and Isaac Lehman's was Lehman Grove. The largest gatherings were the community Summer Bible School picnic and the Fourth of July celebration.

On the Cover:
The Berne-French High School marching band led the Centennial parade in 1952. The people of the community had congregated on the sidewalks for many blocks to watch the parade. The band, under the direction of Dr. Freeman Burkhalter, played stirring music as they proceeded west down Main Street. The twirlers were Roselind (Yager) Kirchhofer (deceased), center, and Sharlene (Huffman) Lehman at the far right. Their outfits were red skirts, white blouses with black cotton vests trimmed with silver braiding, white boots, and hats imported from Switzerland.

IMAGES
of America

A SWISS COMMUNITY
IN ADAMS COUNTY

Naomi (Eugene) Lehman

Naomi Lehman

ARCADIA

Published by Arcadia Publishing,
an imprint of Tempus Publishing, Inc.
3047 N. Lincoln Ave., Suite 410
Chicago, IL 60657

Printed in Great Britain.

Library of Congress Catalog Card Number: 2001094338

For all general information contact Arcadia Publishing at:
Telephone 843-853-2070
Fax 843-853-0044
E-Mail sales@arcadiapublishing.com

For customer service and orders:
Toll-Free 1-888-313-2665

Visit us on the internet at http://www.arcadiapublishing.com

This book is dedicated to the Heritage Room of the Berne Public Library,

To the professional staff who organizes and
preserves significant historical materials,
and
To the volunteers who contribute in the sustaining
of the history and heritage of our community.

CONTENTS

ACKNOWLEDGMENTS

To the Swiss Heritage Society I communicate my thanks and appreciation for the helpful support and encouragement given throughout the development of this volume, and for allowing us to use their photo collection.

Obviously it is no easy task to put into a small volume all the material submitted. For this reason, it was agreed that photographs would be included on the basis of quality and pertinence to the scope of this work. There have been many events, people, and traditions that have not found a place in this volume. A sincere apology is given that all could not be published.

I communicate my thanks and appreciation to:

Claren J. Neuenschwander—for the contribution of historical background information.
Karen Adams and Cindy Herman—for their expertise, skill, and tireless effort in the planning and production of this volume.
Max Haines and Marvel Zuercher—for their professional help as proofreaders.
Ann Fugman and my editors at Arcadia Publishing—for their help and encouragement.

Photo contributions are hereby recognized from:

Steve Hult
Melvin Liechty
Heritage Room, Berne
Public Library
Swiss Heritage Society
Bryce Christy
Rose Frauhiger
Mayor Blaine Fulton
Wilmer Lehman
Marge DeArmond
LeRoy & Barb Yoder
Ardyth and Valier Flueckiger
Claren J. Neuenschwander
Adam Barrone
Adam and Julia (Beitler)
Liechty

Pauline Lehman
Howard Baumgartner
Corrine Lehman
Elmira Wulliman
First Missionary Church
Saundra Minger
Paul Herman
Rhona Norris
Kenyon Sprunger
Margo Graber
Marvin Hirschy
Ruth Gottschalk
Christine Purves
Lucille Zuercher
Paul Neuhauser
Earl Habegger

Richard Beitler
Rod Liechty
Gene and Nancy Subler
Fred Bixler
Stuart Lehman
Courtney Herman
Claren "Clez" Lehman
Colleen Allmandinger
Victor Gerber
Roger Lee Sprunger
Dwight Habegger
Dave Nussbaum
Fred Clauser
Millard Moser
Joni Lehman
Ruth Steury

INTRODUCTION

Agriculture had been a way of life for many of the Swiss immigrants. These early settlers of Adams County had been forced to move onto the plateaus of the higher altitudes in Switzerland. The area was usually rocky with very little topsoil. They could rent but never own the land. All the fieldwork was done by hand with simple tools.

Coming to Adams County was a tremendous change for the Swiss settlers. The climate was much better for agriculture, the topsoil was deep, and land was easily acquired. The land needed to be cleared of the trees and then drained, but the reward of that labor was for the family.

The wheel of this piece of discarded machinery shows how quickly it can be entwined into the surroundings. The wheel is evident with the straight metal spokes as the tree has grown into it. This is symbolic of the culture of our area. The Swiss have been surrounded with a new country, a new language, and a new opportunity.

Through the experiences of 150 years, we recognize that no two facets of the culture can be separated. The futile attempt to pull one portion from another only results in the failure to see the complete life of a community. It is heartening to see that the new settlers, just ordinary people, made such great achievements and accomplishments. To these Swiss immigrants, life was to firmly grasp the ideal to which the soul is dedicated—love of God, love of both family and friends, and respect for others, especially the elderly.

The heavily forested and swampy land was cleared and tilled. Homes were constructed, businesses—many of which became old established family endeavors—were opened, and churches were built. Even today this small city of 4,000 inhabitants maintains a definite Swiss atmosphere. The community is influenced by its craftsmanship and its desire for precision and excellence.

The necessary concern of each for the other would forever distinguish the Swiss from their counterparts. And yet it is often the small things that remain most vivid in our minds: family gatherings, neighborliness, beautiful sunsets, hearing the wind in the oak trees, and seeing the spring beauties in the woods.

The fact that the year 2002 marks the anniversary of the settlement of this area is significant and meaningful. In this year of celebration, there has been more than the usual interest in the life and times of the Swiss immigrants. The people have not forgotten the virtues, the character, and the faith of their ancestors.

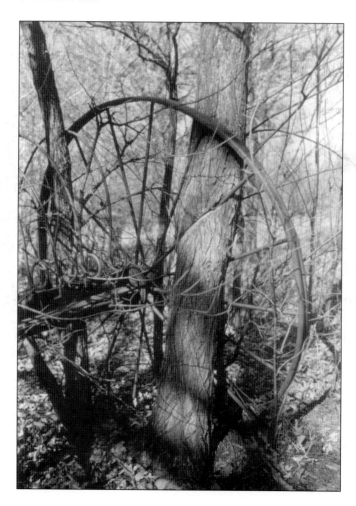

One

A BACKWARD GLANCE

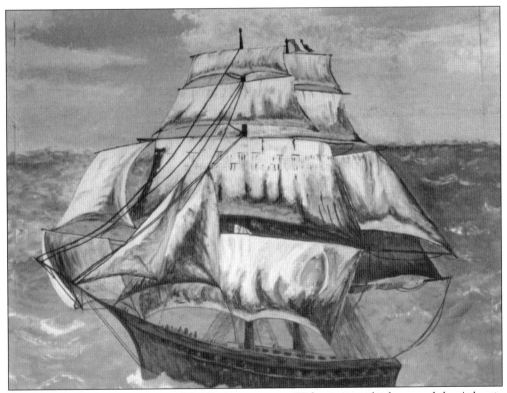

Shown is an artist's conception of the cotton transport *Hahnemann*, which crossed the Atlantic in 1852, with some 80 Swiss for settlement here. Its dimensions were 123-feet long and 22-feet wide, with only minimal accommodations. During the 41-day journey, many storms were encountered, and many became ill. During the arduous journey, three of the Swiss children died and were buried at sea.

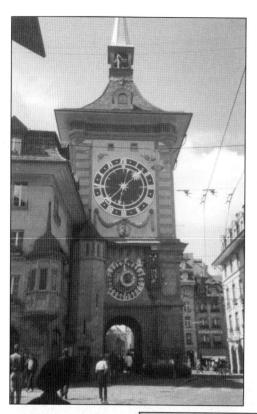

Our little city is the namesake of Bern, the capital of Switzerland, located in the Canton of Bern. Named by a duke after the first thing he saw, a bruin or bear, Bern is the home of the *Bärengraben* or bear pits. First built in 1513, this still is a great tourist attraction.

Most of the Adams County Swiss came from the Canton Bern area. While most immigrated with family or church friends, many acquaintances were left behind. Some came in later migrations, while others chose to remain in Switzerland.

Most of our predecessors were farmers who had developed a supporting trade such as weaving, bookbinding, or woodcarving. All were accustomed to a meager existence. Many had lived in mountainous terrain, excluded from the culture and grouping of other Swiss citizens. Their religious beliefs had created this division. We can only imagine the difficulty they faced trying to eke out a living in the higher altitudes. However, the decision to leave must have been a difficult one to make. The availability of plenty of good farmland to support their large families must have made America look like a land of golden opportunity.

Correspondence from other Swiss families in Sonnenberg, Ohio, assured them not only of a better way of life but also of assistance in getting started.

After securing passports from the Canton of Residence in Switzerland, a contract was signed with the American Shipping Company to sail to the United States from France. Each passenger over 10 years of age was allowed 200 pounds of baggage, and children under 10 were allowed 100 pounds of baggage at no extra charge.

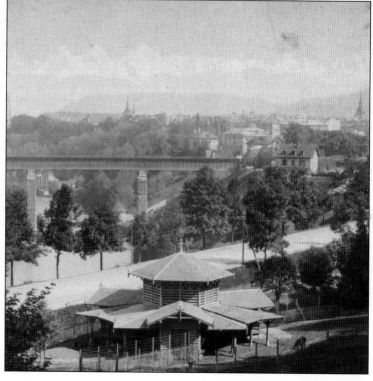

Each family was promised by the sailing company good lodging, daily coffee with sugar and bread, a midday meal of strong soup, meat, and vegetables, and a supper consisting of soup, fried meat, and salad with variation. The provisions for the journey were prescribed for each family as follows (taken from sailing contract for Christian B. Lehman):

5 pounds fresh bread
35 pounds zwieback
4 pounds butter
14 pounds smoked meat—beef and pork
2 pounds salt
5 pounds flour
5 pounds rice
168 pounds potatoes or 20 pounds beans and peas
2 liters vinegar.

Sometimes the wind would be contrary, and they would drift backwards. When bad weather pushed the passengers below the deck into closed hatches, disease and hardship took their toll. They were subject to all kinds of diseases, such as scurvy, typhoid, dysentery, and small pox. For the most part, these people had never been on a ship and were not prepared for the hardships they faced.

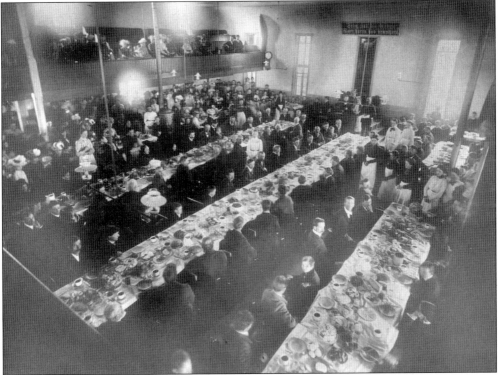

The Jubilee celebration (April 1902) at the Mennonite church honored the arrival of the Swiss immigrants who came in 1852. The table planks went across pews, and the people sat sideways on the pews to eat. Gaslights were in place. The table waitresses were the second generation of the immigrants. The clock in the upper center was moved from this church to the new one in 1912. (Photograph by Shalley.)

Deacon David Baumgartner wrote a letter to friends in Switzerland of his journey from Wayne County, Ohio, to Adams County, Indiana, when he was 76 years old.

We were $90.00 in debt when we arrived in Ohio. After more than two years of work by our entire family we were out of debt, but we had no land. We heard that land was available from the government in Indiana for $200 for 160 acres. Good friends loaned us enough money to buy [one half section, 320 acres], so we went to Indiana in August 1839. Twice we had to remain in the woods all night. Each of our families had one wagon with two oxen and two cows. When we came to our land we found my brother was sick with a fever. There was no room for us in his small log house. We had to live nine days in a hut made of leafy branches. We dug a well for water and then made a log house. Around us is still all timber and no road was cut out. When we seek our cows and cattle there is danger of becoming lost in the forest. We were afflicted with sickness. The three brothers had the chill fever, mother was troubled with rheumatism and Barbara (a niece) died of consumption (tuberculosis) after suffering for 22 months.

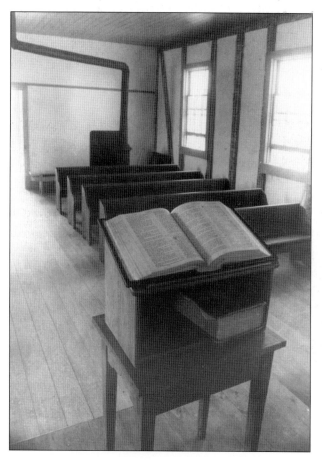

In the Baumgartner Church, now restored at the Swiss Heritage Village, the simplicity of worship is evident. This was the first Mennonite fellowship established in Indiana. The slightly raised platform gave the congregation a good view of Deacon Baumgartner as he read from the open German Bible and preached in Swiss. The women sat on the side in view, and the men sat on the other side of the center aisle. During the winter, the only heat came from the stove in the background. The lengthy stovepipe gave additional heat in the building. There are two hooks from the ceiling to hang lanterns for light. (Photograph by Steve Hult.)

Widow Elizabeth (Zaugg) Amstutz and her five children left their home in Lago, Switzerland, for America in 1886. They settled in Berne, where several of their friends and relatives were already established. Her children, the youngest of which was nearly 15, quickly found work or places to stay as hired hands or domestics. She died at age 92 in 1928.

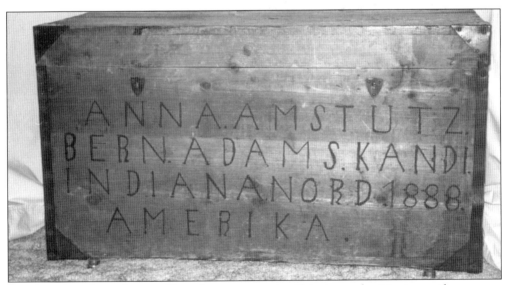

Daughter Anna's trunk arrived here by separate train. Shipping authorities in a wide area automatically sent packages from Switzerland with irregular addresses to Berne, Indiana. They knew that the local postmaster could sort it all out and if the addressee were not local, he would reship the item to the proper Swiss settlement.

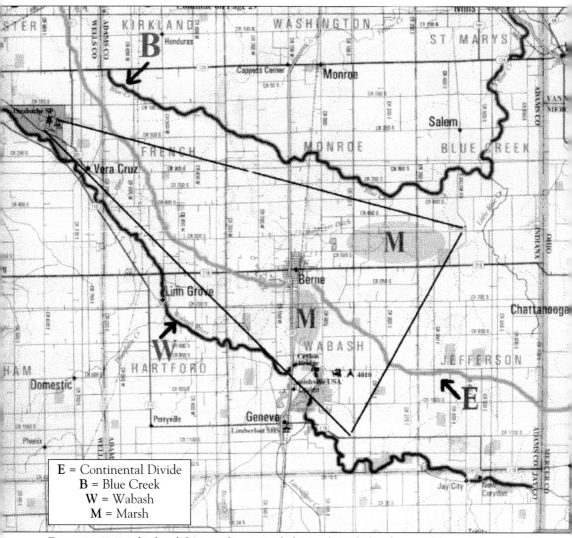

For many years, the local Swiss colony guarded its culture behind natural boundaries afforded by the flood-prone Wabash River, the boggy Blue Creek, and various marshy swamps. Through the center of this area runs the Continental Divide. Water to the north of the divide drains through to the Great Lakes and south drains to the Mississippi River. The first deep penetration of this triangular-shaped enclave by the "American" culture came about with the coming of the railroad in 1872. The result of this prolonged isolation is still noticeable. The Berne community of Adams County, Indiana, is considered the largest Swiss ethnic center in America. (Map by Claren J. Neuenschwander.)

At first when clearing the forest, the best hardwood logs went for cabins and outbuildings. Much of the rest was simply burned on site. Later lumberyards were started, but these took only the finest logs. What was left was firewood which went to heat homes and provide fuel for locomotives, threshing machines, and other steam-powered equipment.

The first house of Johann and Katharina Huser Soldner in the Berne community shows the primitive shelters that were erected. To have better weather for crossing the Atlantic, many immigrants arrived in New York in the middle of summer. By the time they came to Berne, it was late summer or early fall. Homes had to be built quickly to provide for the family for winter.

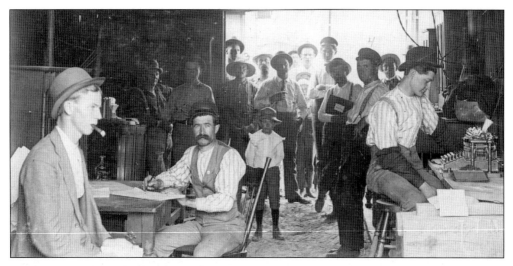

The first train to arrive in Berne was on Christmas Day 1871, consisting of only a locomotive, tender, boxcar, and caboose. With the coming of the GR&I (Grand Rapids and Indiana) Railroad, the community was able to purchase goods previously not deliverable because of inadequate roads. As the train left the station belching black smoke and soot, the people sensed the dawning of a new era of trade and opportunity. The railroad station was completed in 1872, on the west side of the tracks, a short distance south of Main Street. Apparently, trains ran on schedule as there was no seating in the waiting room until about 20 years later. It appears that workers wore striped shirts and suspenders and Louis Habegger, teletype operator, also wore sleeve protectors. The man smoking a cigar is Morris Ehrsam. At a time of mud pikes, the rails were always high and dry. This railroad bridge over the Wabash between Berne and Geneva was used year-round. During winters, the locomotive's cowcatcher was an excellent snowplow. People often posed on the bridge as they walked to school, church, or town, and over the course of time numerous people were struck and killed by trains while walking on the track.

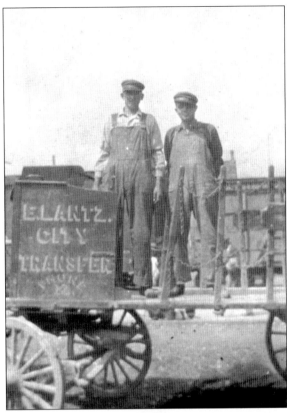

The first drayman began his service in the 1870s. After the railroad came, several draymen were kept busy. All local freight that came on the trains had to be transported to the proper destination. There were materials for the factories, tubs of cheese for the Berne Meat Market, and grocery staples that arrived in barrels and boxes to be delivered to the local stores. Sometimes these wagons were called Nar-Tar (Narrow Tire) wagons. Ezra Lantz also held the contract to sprinkle and sweep Main Street.

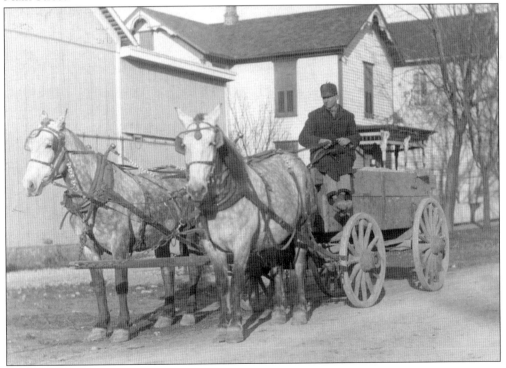

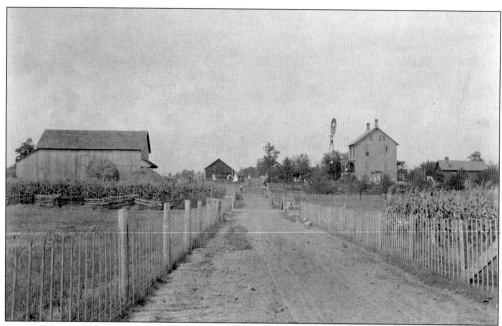

The combination wire and picket fence provided a much more secure livestock enclosure than did the rail fence shown in left background. This commercial fencing probably became available locally after the coming of the railroad in 1872. The long lane came about because dry storage basements were needed, and the nearest high ground from the road determined the location of the house.

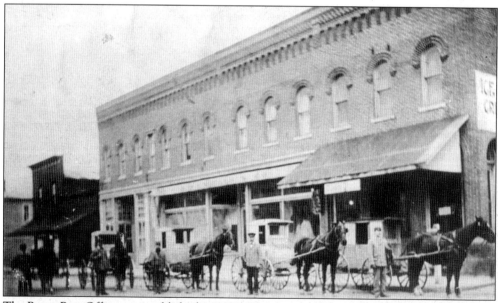

The Berne Post Office was established in 1872. The Canoper Post Office, located east of Berne, which had served the community since 1858, was discontinued. Both incoming and outgoing mail was moved by train. In 1903, the first rural delivery route was set up with Amos Burkhalter as the carrier. Within two years, Bertram Parr, Simon Lehman, Otto Frantz, and Elmer Eley assumed four more routes. A 1906 publication pointed out that "not one of them has ever missed a day they were to be out on the road."

18

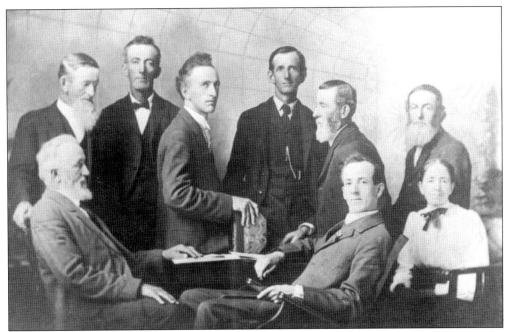

Many who joined our colony were Swiss, like the Philip and Mary (Richer) Hirschy family. They had lived for a while in Alsace, a French province that bordered Switzerland, because during the Reformation they were afforded more religious freedom than in their homeland. The Hirschys came here in 1835, and posed with their family about 1905. Noah, center front, became the first president of Bluffton College in Ohio.

In 1918, Clinton Habegger was about to make the 3-mile trip to see his fiancé, Lydia Neuenschwander. He chose the convertible family buggy so, in case of bad weather, he could readily raise the top and snap on the side curtains. Although there were quite a number of cars at this time, they were not nearly as reliable as a horse and buggy on muddy country roads.

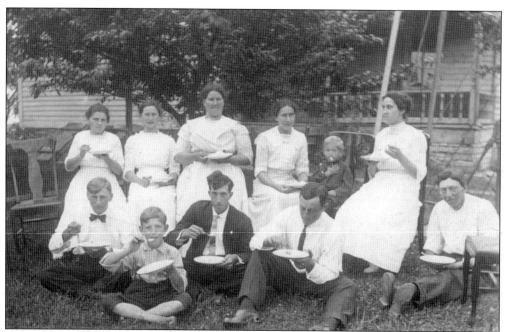

Homemade ice cream has been a favorite of the community. In June 1913, Jake and Ida Moser entertained members of the family. From left to right are: (front row) Herman Lehman, Frank Moser, Wilbur Lehman, Noah Neuenschwander, and Jake Moser; (back row) Mollie Lehman, Lydia Neuenschwander, Ida Moser, Elma Neuenschwander, Harry Moser, and Della Neuenschwander.

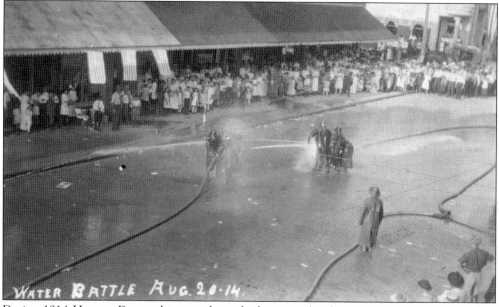

During 1914 Harvest Days, a big crowd watched a water battle on Main Street between the "East" and "West" teams of the Volunteer Fire Department. Reportedly, some of the spectators on Main Street got too close and ended up soaked. The sport was very competitive between neighboring town fire departments for many years.

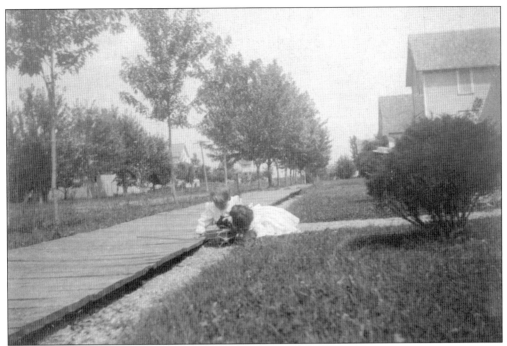

At the turn of the century, wooden sidewalks provided a surface for children's play activities. Here it appears the two girls have made a pit stop to adjust their toy wagon. The two rows of young maple trees lined Main Street when it was still plain dust or mud. Soon after the street was bricked, in 1901, the wooden sidewalks were replaced with sandstone slabs and later with concrete.

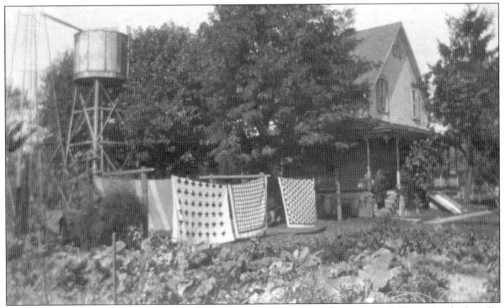

Quilts were made from leftover cloth scraps at a time when the women-folk made clothes for the entire family. This was, apparently, a modern farm home, as the windmill filled the elevated water tank to provide a pressure system. This system eliminated inside hand pumps in the kitchen or washroom.

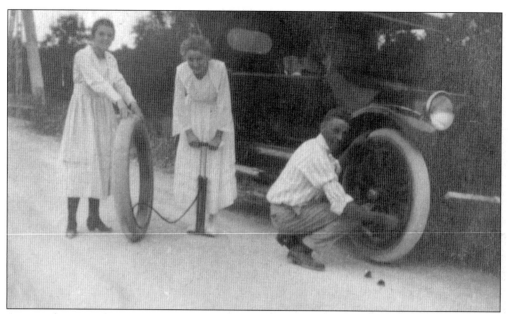

Among the many hazards of early car travel were flat tires, and motorists did not venture far without at least two spares. A 1918 AAA Highway Map recommended the A.J. Moser Garage for repairs and the Alpine Hotel in which to bide time if your car broke down on the O.I.M. (Ohio-Indiana-Michigan) highway, which went through Berne. Generally, this route is now known as U.S. 27.

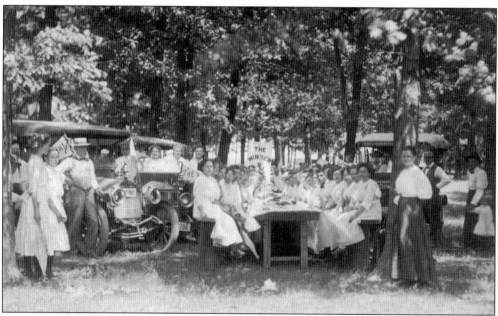

Isaac Lehman permitted picnickers to use his grove on the condition they close the gates when leaving. It seems they often forgot, and neighbors would complain about his cows roaming their gardens. In 1927, Lehman donated his woods to Berne, and picnic benches and tables were soon installed. There was some grumbling when the town later designated parking areas, and food and dishes had to be carried to the tables.

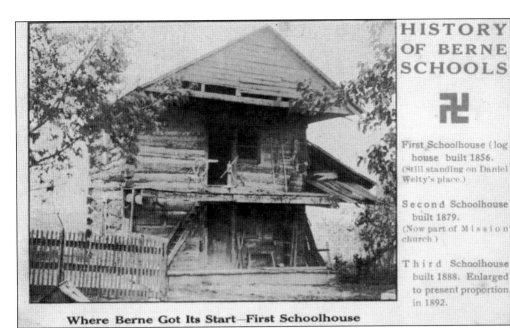

First Schoolhouse (log house built 1856. (Still standing on Daniel Welty's place.)

Second Schoolhouse built 1879. (Now part of Mission church.)

Third Schoolhouse built 1888. Enlarged to present proportion in 1892.

Where Berne Got Its Start—First Schoolhouse

The "Greek Cross," an ancient symbol of good luck, dates back before the time of Christ. It was widely used as a decoration. This "Greek Cross" (swastika) was used as an emblem of Nazism by Adolph Hitler in the 1930s, long after this print was made. Now it is one of the most hated symbols in human history. In 1856, Johann Sprunger and his boys built a school, and his son Abraham J. became the teacher—all for free. This impressed the township trustee, and the very next year the school was replaced with Monroe Township No. 8.

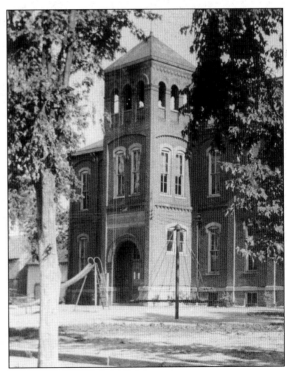

As soon as Berne became incorporated in 1888, a two-room brick school was built where the City Building is now located at 150 West Franklin. Four years later, 6 rooms were added, and in 1909, another addition made it 12 rooms. Its two-year high school began in 1888, with two graduates in 1901. Rural students who wanted to attend high school had their tuition paid by their township.

23

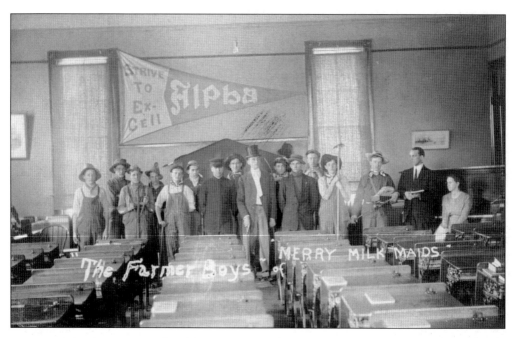

Music and drama were considered necessary in each student's high school experience. Shown are the "Farmer Boys" and "Milk Maids," who put on the *Merry Milk Maids* musical in 1914. The stage was at the west end of a large second-story study hall built onto the school in 1909. In 1904, two literary societies were formed and all incoming freshmen were chosen, by lot, to be either an Alpha or Arena. Competitive contest results were totaled each year, and the winner's banner was designated as the assembly hall's name for the next year. The rivalry became so keen that painted signs of "Alpha" or "Arena" began appearing on Berne's water tower tank. As a result, the societies were disbanded in 1946.

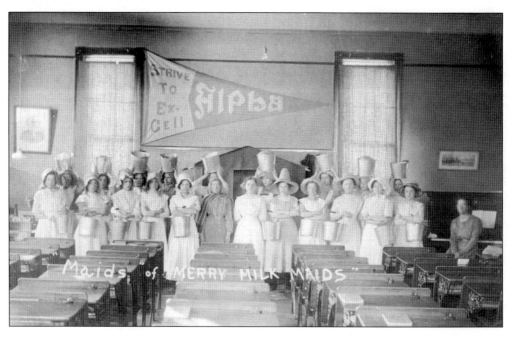

In 1939, a new building was dedicated to house grades one through twelve. Like many other new schools at the time, most costs were absorbed by Franklin Roosevelt's "New Deal" efforts to combat the Great Depression. The land was donated by Sam Nussbaum as part of his housing development. The Class of 1940 was the first to graduate from this building.

The local Swiss colony started in rural French Township in about 1838, and Berne was founded in 1872. The two merged their school systems into the Berne-French Township Schools in 1948. In a larger consolidation in 1963, which involved five other school districts, the South Adams Schools was formed after a favorable vote. In 1973, the present junior-senior high school was completed.

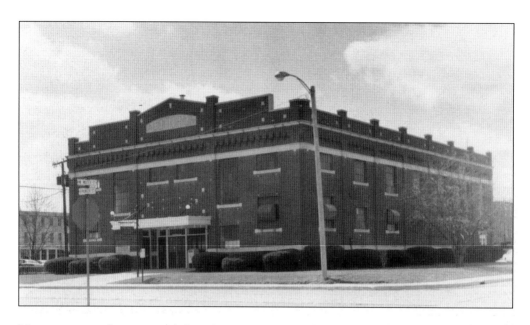

Many townspeople recognized that if a town is to succeed there must be a community spirit. This rectangular brick and concrete structure was built in 1921. It was designed for lecture series, school plays, musical entertainment, and sporting events. The architect, Abe Bagley, also supervised its construction. The lighting, acoustics, and ventilation systems were excellent and well ahead of the times. This building was considered by Civil Defense to be one of the safest buildings in town. The first entertainment presented in the auditorium was given by the Lieurance Symphony Orchestra on Thanksgiving evening, 1921. Since 1960, the Berne Public Library has occupied this building.

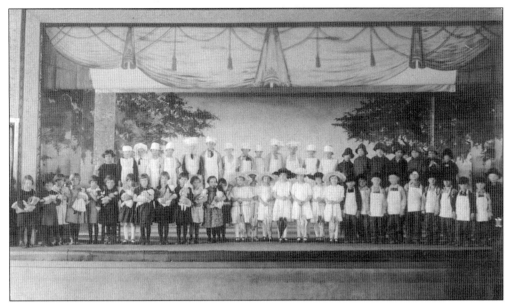

The stage facilities of the auditorium were greatly used by both the elementary and high schools. Because of these fine facilities, the new high school, completed in 1939, did not include a stage. It was not until 1953 that the school was remodeled and included its own stage and music rooms. The time period of this school group is about 1925.

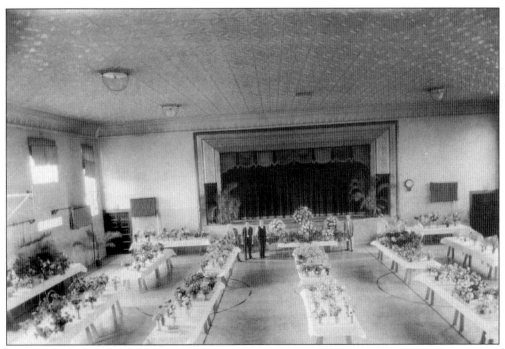

The Berne Auditorium was built by local stock subscription as a multi-purpose community center. The local school used it regularly, but so did the public. There were many banquets, which customarily included stage entertainment. Here the local Flower and Garden Club has prepared displays for its show and judging.

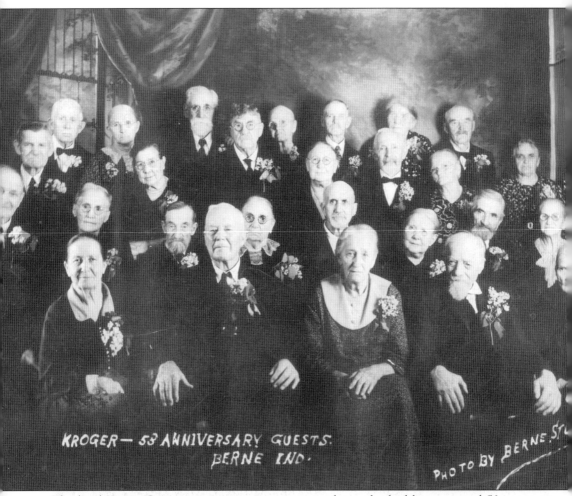

KROGER — 53 ANNIVERSARY GUESTS.
BERNE IND.

PHOTO BY BERNE.STU

The local Kroger Grocery store gave recognition to those who had been married 50 or more years. In our community, marriage is held as a sacred vow. It is not unusual that we sense the strength of the home as steady and sturdy. This photo was taken prior to 1936. From left to right are: (front row) first person unidentified, Mr. and Mrs. Sam Hirschy, and Mr. and Mrs. Emmanuel J. Liechty; (second row) Mr. and Mrs. John B. Welty, Mr. and Mrs. Chris Liechty, Mr. and Mrs. Christian C. Neuenschwander, and Mr. and Mrs. Peter Burkhalter; (third row) Mr. and Mrs. John Bucher, Mr. and Mrs. Sam Soldner, and Mr. and Mrs. Sam Sigrist; (last row) Mr. and Mrs. Dan Stuckey, Mr. and Mrs. Ben Nussbaum, Mr. and Mrs. Christian Sprunger, and Mr. and Mrs. Sam Steiner. (Photograph by Berne Studio.)

Two

BUSINESSES

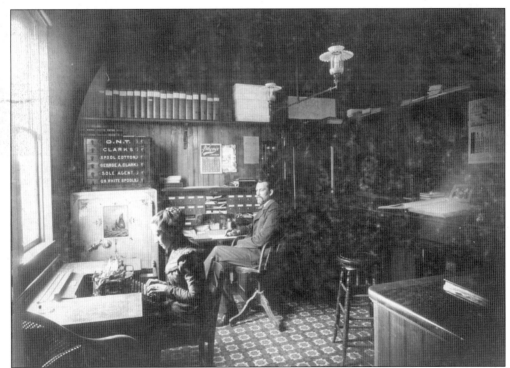

Beginning in 1880 until his death in 1932, Japhet "Jeff" Lehman was Berne's leader in social, political, business, industrial, and religious development. Early on, he was associated with a general store, and it is likely that the above setting is that of his office. Among many other ventures, he was the first president of the town council, fire department, and chamber of commerce. He also served as postmaster and bank president.

The first brick building in town, J.A. Sprunger & Co. shown above, was built in 1881 as a department store. It was built with bricks from neighboring Decatur because there was no brickyard in Berne at that time.

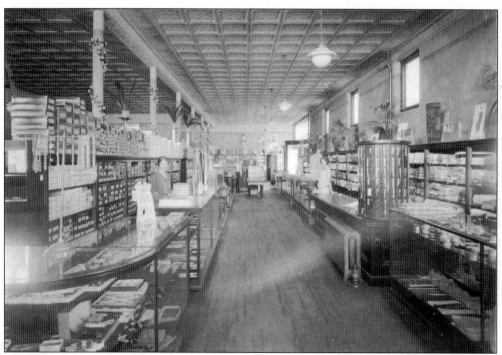

This is the women's department of the J.A. Sprunger & Co.'s successor, Sprunger, Lehman & Co. The men's department of haberdashery items was of equal size in the same building. The store carried a complete line of dry goods, groceries, rugs, and other floor coverings. The stock completely filled their two floors and the basement. Later it became Lee's Department Store, and presently it is the site of The Nut Tree.

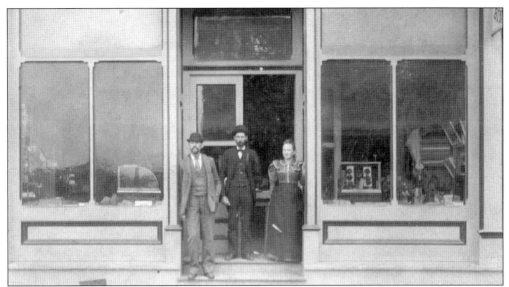

Joel Welty opened the first book store in Berne in 1882. In 1884, at the General Conference in Berne, the Mennonites offered to purchase the book store and enlarge it into a publishing house as well as a book store. Mr. Welty continued to manage the publishing concern. The sign in the upper right-hand corner indicates the book bindery. Though the name has been changed several times, today's Provident Book Store is the oldest business in Berne that has been in operation continuously.

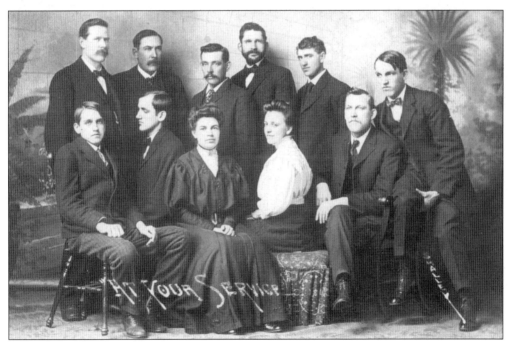

The employees of the post office and the book store are identified from left to right: (front row) Clarence Lehman, Adolph Lehman, Salome Luginbill, Helena Liecht, and J.F. Lehman; (second row) Amos Burkhalter, Bert Parr, Simon Lehman, Otto Franz, William E. Teeter, and Clinton Lehman. (Photograph by Shalley.)

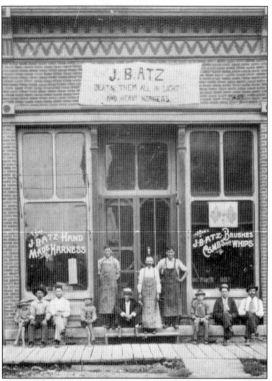

In 1886, Jacob Atz purchased the harness shop that had been established by D.E. Allen in 1876, when Berne was only four years old. In the early 1890s, he built this new building at what is now 156 West Main (Sprunger Shoes). Bench ledges on storefronts were typical on muddy Main Street, as were wooden sidewalks that were later replaced by cut sandstone slabs.

Sprunger Shoes, located in the center of Berne's downtown business district, opened its doors in 1908. Benjamin Sprunger, the original proprietor, retired in 1955. His grandson, Kenyon Sprunger, is the third generation of the Sprunger family to provide for Berne's shoe needs on Main Street. Swiss was both understood and spoken in the store to help those not familiar with English. To the left is the stairway to the second-floor apartments in the adjacent building. To the extreme right is the fire department door.

The first part of Berne Grain and Hay Company was constructed in 1873, by Philip Sheets. The ownership changed several times, and each new owner expanded the service. In addition to grain, hay, and livestock feed, they sold seeds and flour. They had a huge coal elevator with a capacity of 800 tons. On April 16, 1930, the operation was destroyed by fire.

It is interesting to note that even in the advertisement, there is no address needed. In a small community it was common knowledge where businesses were located. For many years, people knew where everyone lived in town. The spirit of neighborhood and friendship still exists in the community.

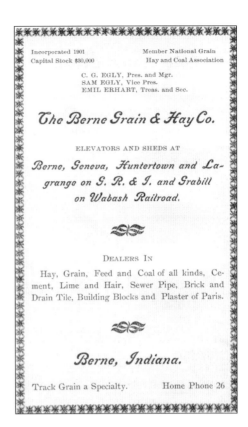

Incorporated 1901 Member National Grain
Capital Stock $30,000 Hay and Coal Association

C. G. EGLY, Pres. and Mgr.
SAM EGLY, Vice Pres.
EMIL ERHART, Treas. and Sec.

The Berne Grain & Hay Co.

ELEVATORS AND SHEDS AT

Berne, Geneva, Huntertown and Lagrange on G. R. & I. and Grabill on Wabash Railroad.

DEALERS IN

Hay, Grain, Feed and Coal of all kinds, Cement, Lime and Hair, Sewer Pipe, Brick and Drain Tile, Building Blocks and Plaster of Paris.

Berne, Indiana.

Track Grain a Specialty. Home Phone 26

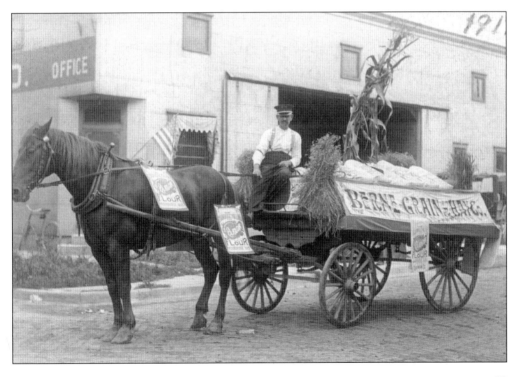

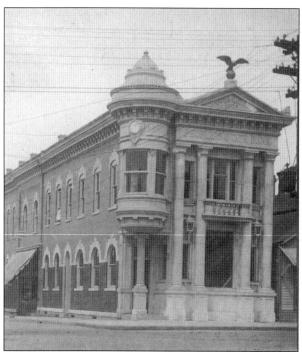

The original brick building, located on the northeast corner of Main and Jefferson, was a clothing store before being acquired by the bank. Its façade has been considered Berne's downtown architectural gem since being remodeled in 1909. The People's State Bank, organized in 1903 during a boom era, became a victim of the Great Depression in 1935. Rudolph R. Schug, first president, also served as liquidator.

Grover W. Neuenschwander purchased this turreted building, which then housed his Pearl Oil office as well as a ladies dress shop, a real estate office, barbershop, insurance office, beauty shop, and a longtime dental office in the second-floor turret among other concerns. It has been an uptown landmark for nearly a century.

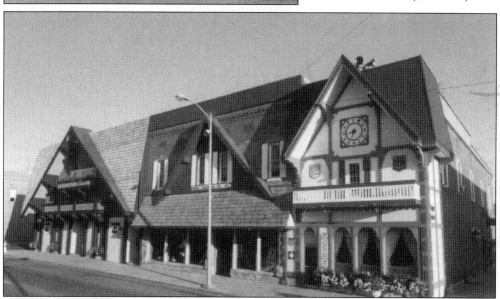

The First Bank of Berne, at the far left on the south side of Main Street, opened in 1891. Before that, settlers found ingenious ways to hide their gold and silver. After the railroad came in 1872, many rode to Decatur for banking. Supposedly C.A. Neuenschwander, a Mennonite church treasurer and future bank president, would step on the scales in the train depot to verify the deposit money by weight. When the Swiss came here, they had little nostalgia for their beautiful homeland where their religious freedoms had been limited. In later years, all was forgiven, and businesses began remodeling with Swiss fronts on their buildings as an economic development strategy. The First Bank of Berne's façade design (1975) was the work of Roger Lee Sprunger, local furniture designer.

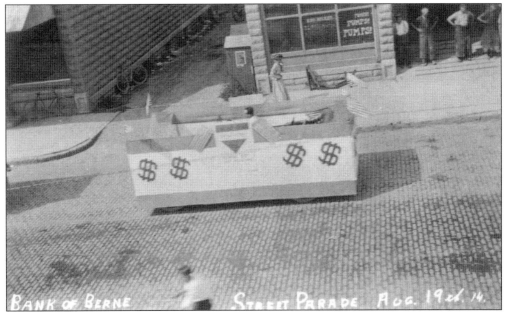

On the brick Main Street, the parade of 1914 hesitates a moment in front of the Abe Hocker business. He was a blacksmith and also an inventor. He developed and manufactured the "lightening post auger" and the "everlasting" cistern pump. Both inventions were reliable for the buyer and successful for the inventor. Mr. Hocker developed the first bathtub in Berne for the Deaconess and Orphans Home. It was made of wood and lined with tinned copper.

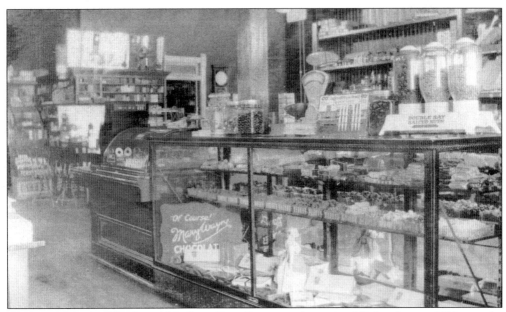

The interior view of the Stengel & Craig Drug Company shows the delight of every child—candy. Christian Stengel and his brother-in-law, John Craig, bought the store in 1892. The first soda fountain was installed here in 1900. The one-time famous ice cream parlor with the wire-backed chairs made for a pleasant, refreshing stopping point in downtown Berne. Following the fateful fire in 1918, when Mr. Craig was killed, Ernest Stengel, son of Christian, became a partner.

Sam Lehman, funeral director, built this home in 1903 at what is now the southwest street corner of Wabash and Lehman. (The large house was adequate for his family of 11 children.) In another building, he housed both high stepping horses and slow plodding draft horses. He had white horses that were used for children's funerals. He had two hearses, one for children and the other for adults. Other funeral choices were harness color and whether the black carriages would be decorated or plain.

Henry Schindler Samuel Lehman Samuel S. Egly

Schindler, Lehman & Co.

Furniture and Undertaking

(*Licensed Embalmers*)

A Complete Line of Choice and Up-to-Date Furniture always on hand.

PHONE 115 NIGHT CALLS ANSWERED PROMPTLY

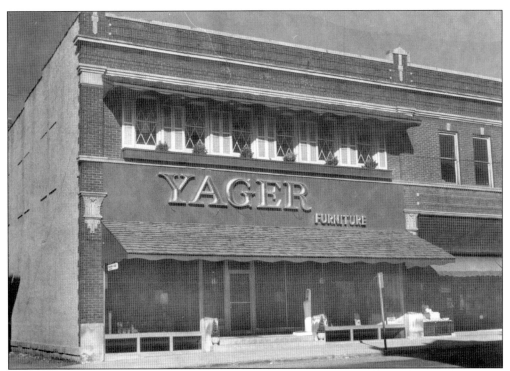

Established in 1910 as Bierie and Yager Furniture and Undertaking, Yager's is the oldest family-owned furniture store in Berne. Four generations of the Yager family have been associated with the business with Mark Smith, great-grandson of one of the founders, presently a member of the firm.

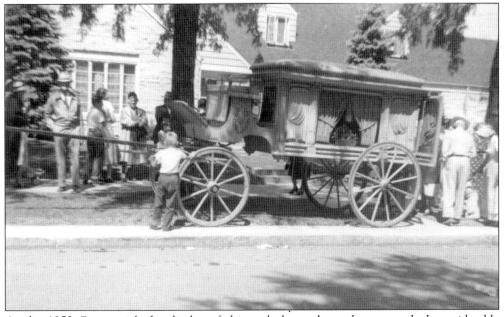

At the 1952 Centennial, the display of this early horse-drawn hearse sparked considerable interest. It was in the front lawn of the present-day Yager-Kirchhofer Funeral Home on West Main Street.

The present Main Street location of the Berne Hardware Company has been its home for over 100 years. In 1900, Schug Brothers' Hardware built the new brick block, and in 1909, they sold their business and Berne Hardware was formed. Berne Hardware was joined by Lehman Brothers' Hardware in 1928. Through the years, Berne Hardware has sold not only hardware, but also trucks, cars, gasoline, furnaces, tractors, and combines, and operated a tinning business. The photo shows a lineup of new automobiles at their "Filling Station," located on the curb.

Abraham J. Moser was the organizer of the A.J. Moser & Co. auto dealership on West Main Street. In 1914, they became affiliated with the Ford Co. Their large garage and well-equipped mechanical shop were the best available for miles in every direction. The changes in personnel over the years have not diminished the attitude of service for the public.

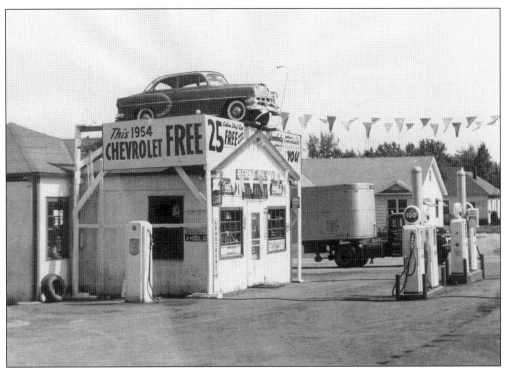

Hoosier Pete Station, at the corner of Hoosier Street and U.S. 27, became Berne's first independent filling station. It was closed during World War II because of gasoline shortages. After 1947, new managers Willard "Bill" Wulliman and Maynard "Miz" Lehman came up with a novel promotional idea. They issued drawing tickets on a new 1954 Chevy to their patrons. Clyde Harden was the winner. The intrigue still persists—how did the car get up there?

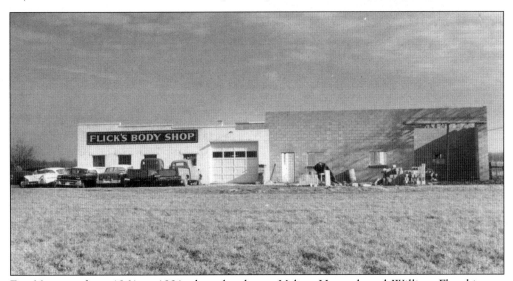

For 30 years, from 1961 to 1991, three brothers—Valier, Howard, and William Flueckiger—operated a full-service automobile body shop on Parr Road, east of CTS. The photo shows the building expansion that took place in 1969. Their expert workmanship was not only the ticket to success but to the constant demand for their work. Joe H. Construction now uses the building.

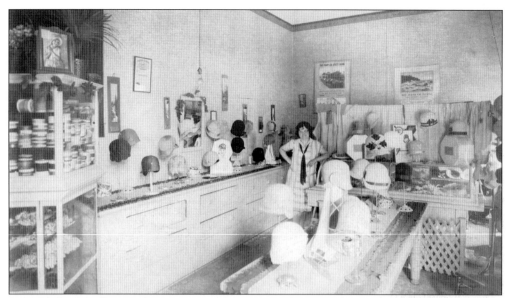

Miss Gladys Stauffer was the proprietor of the Personality Hat Shop located on Jefferson Street in what is now part of the First Bank of Berne building. She had previously worked in Ft. Wayne to gain some experience in sales. In her advertisement she used "Above All—The Right Hat" as her motto. She helped ladies understand the secret of a charming appearance. She stocked a vast selection of very good quality hats at reasonable prices.

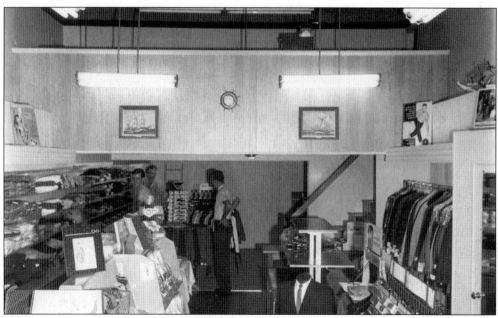

Shown above is the interior of Stan's Men's and Women's Apparel. The history of Stan's goes back to 1928. It was originally known as the Habit and was located in the west half of the downtown location of the First Bank of Berne. It had been a press shop, shoeshine parlor, and haberdashery, but now features both men's and women's quality apparel. Moved to its present location at 168 West Main by previous owner Stan Brenneman, it is now owned by the Craig Sprungers and Berdell Lehmans.

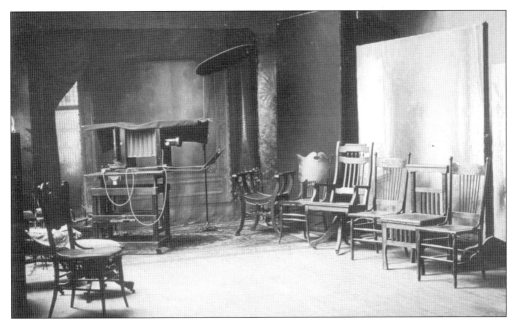

Daniel L. Shalley came here in 1883. After several years as a miller, cook, grocer, and part-time artist who drew "funny pictures," he opened the Berne Studio in 1895. His young son, Earl, went to art school and in 1904, took over the business. Subsequently, he won several honors—his well-known portrait of Nick Gasser entitled *The Hermit's Repast* being widely publicized. He took many pictures of local people before he sold to Jacob Gerber in 1933.

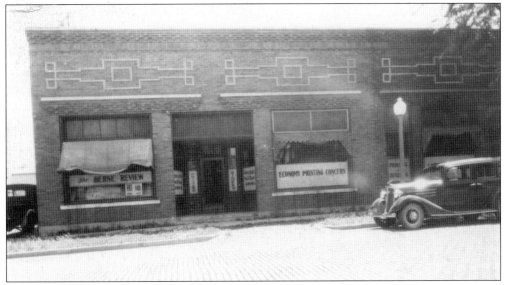

The Economy Printing Concern, begun in 1913 by C.H. Muselman, did commercial printing. Today known as E.P. Graphics, they are located on South Jefferson Street. The firm is a major employer in this community. Mr. Muselman also began *The Berne Review*, a local newspaper in 1925. Following the death of the manager of *The Berne Witness*, the two papers were merged. Today it is called *The Berne Tri-Weekly*.

In 1903, Menno Burkhalter bought a variety store, moved it to 113 West Main, and renamed it "The Fair Store." Two specialties were candies and dishes. The kids got free suckers, and when buying candy, extras were thrown in—just to be fair. And traditionally, future brides like Michelle Graber (center) would choose a dish pattern, which would then be recommended to gift purchasers. The store was in business nearly a century.

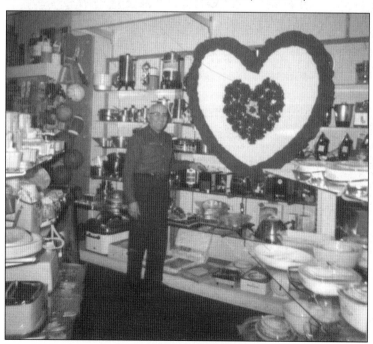

The Serv-Us Store, established in 1928, has long been a fixture in downtown Berne. Shown here is manager Eventt Lehman with a Serv-Us Store tradition, a large heart for Valentine's Day. For years Mr. Lehman would redecorate the large heart to feature suitable gifts for Valentine's Day purchase. Eventt Lehman's grandson, Eventt Norris, presently manages the store.

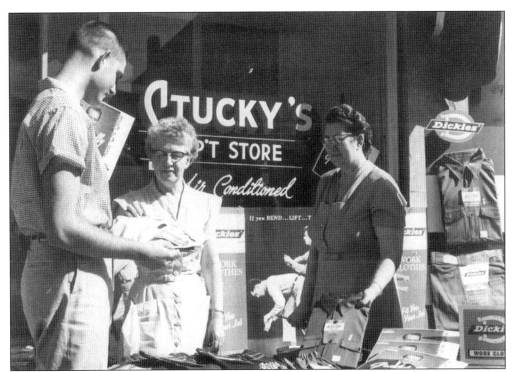

The Stucky Department Store was operated by Mr. and Mrs. Menno Stucky during the 1940s, '50s, and early '60s. Shown in the photo is Mrs. Stucky on the right at a Sidewalk Day Sale. The store was a part of the Easter Sunday fire of 1964. Today this site in downtown Berne is called *Ruhe-Platz* (the Resting Place), which is a miniature park area.

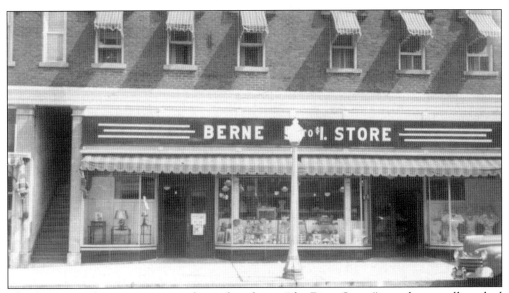

The downtown department store, often referred to as "the Dime Store," was always well stocked with merchandise. Whether sewing supplies, home furnishings, toys, school supplies, or candy was on your shopping list, the Berne 5¢ to $1 Store was visited. The picture shows the store in 1952, during the time that Adam J. Liechty was owner and manager.

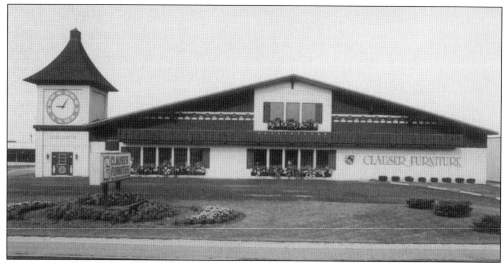

Clauser Furniture began its furniture business in the downtown area as Clauser and Myers Furniture. Following the death of Hobie Myers, Alfred "Tuck" Clauser bought Myers' share of the business and later moved the store to the northern edge of Berne on U.S. 27. The Swiss front on the Clauser Building includes a 55-foot-tall clock tower modeled after one in the town of Bern, Switzerland. Today, Clauser's is owned by "Tuck" Clauser's two children, Fred Clauser and Madelyn Wurster. The area's strong Swiss work ethic has dictated a sense of pride in quality for the entire community. This pride is evident in business as well as well-maintained yards and flower beds.

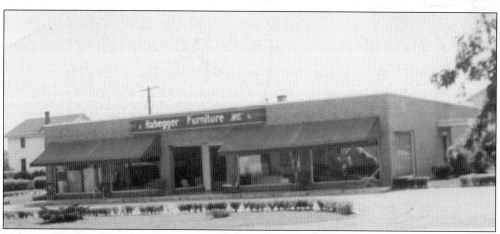

Habegger Brothers Furniture began in 1938, with the 60-by-60-foot building well stocked with furniture, home appliances, accessories, and floor coverings. The business, located at the corner of High Street and U.S. 27, was "out of town" when built. Some people cautioned the four brothers, Clinton, Sylvan, Arley "Pete," and Milo "Mike," that it was a big mistake to be in the country to have a business. But before long, the city grew around the store. The sound fatherly advice given these brothers was to "always be honest and do unto others as you want them to do unto you."

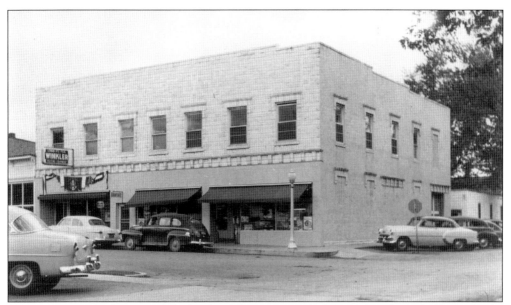

In 1915, some 50 determined high school boys met to find an indoor basketball court. The spacious second floor of this new building, constructed on the southwest corner of Water and Jefferson Streets by the Artificial Stone Company, then became available. The boys would run plays around the two roof-supporting posts to screen their guards, an unfamiliar tactic for teams with outdoor courts. This 1954 photo shows Food Town grocery on the corner and Lehman Heating & Plumbing on the left.

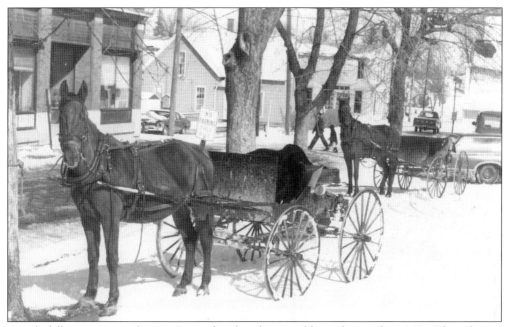

Amish folk wanting to shop in Berne faced parking problems during the 1960s. These horses proudly pose with their buggies by the "No Parking" sign on the east side of Behring near Main Street. The problem was eventually solved for the fast growing Amish population with the construction of three horse and buggy parking barns.

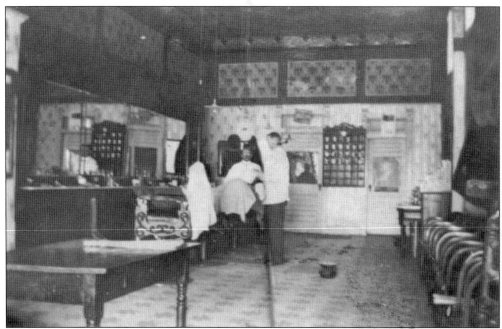

At one time, "Shave and a haircut, two bits," was a common slogan. Many clients were businessmen who needed daily shaves, gossip, and, perhaps, a shoeshine. The spittoon, in the center of the floor, invited demonstrations from those seated that had reputed spitting accuracies. With no waiting customers, it was apparently near the close of the day for the Big Four Barbershop located in the present Palmer House building at 118 West Main.

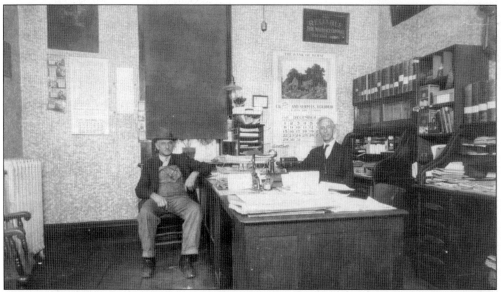

The Hirschy Insurance office was located on Jefferson Street in the First Bank of Berne building. The calendar on the wall from the bank gives the date of the picture as December 1929. Seated behind the desk was Amos Hirschy, who wrote insurance for more than 30 years. Louis Sprunger had come in for a short visit. All electric bills for the townspeople were paid at the insurance office.

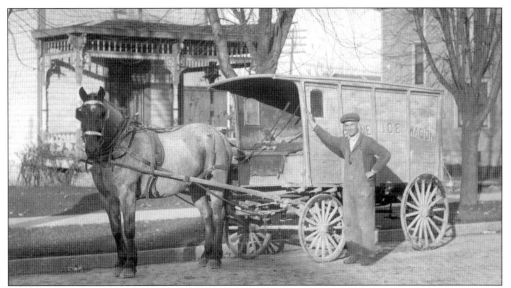

Martin L. Sprunger was known as "Ice Cream Mike." Kids loved to visit his factory, and they also loved to follow his ice wagon—especially on hot days. When he said "whoa" on his delivery route, the kids would eagerly gather around. The contest began when he artfully swung his ice pick on the large block of ice as he designed a cube for the customer's icebox. The cold flying slivers were then fought for as the kids slaked their thirst. Ice Cream Mike would just smile. He hated to waste ice!

The Black Bear Saloon, shown from the alley, was one of several saloons that flourished during the oil-boom days but were closed in 1906 by Circuit Judge Erwin. The saloon owner, Sam Kuntz, was later elected, unopposed, as Berne's Constable. When the brick Berne Witness Building was to be built in 1911 on the northwest corner of Main and Behring Streets, the saloon building was moved and is now the north half of the Farm and Home Center building at 163 North Behring.

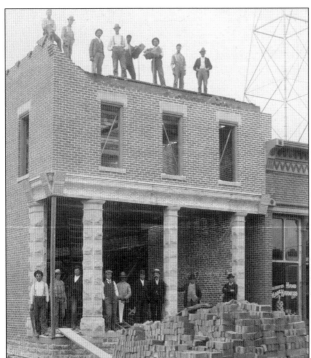

The construction of the City Bakery in 1900 by Emil Pluess and F.G. Eichenberger was a vital addition to the town. On the first floor was a grocery and lunch counter at the front and a dining room and bakery toward the back. In 1916, the bakery had been enlarged, and they baked between 4,000 and 5,000 loaves of bread every week in addition to cakes, sweet rolls, and other favorites. On the second floor were rooms and apartments for rent. This building is the present home of the Et Cetera Ecke.

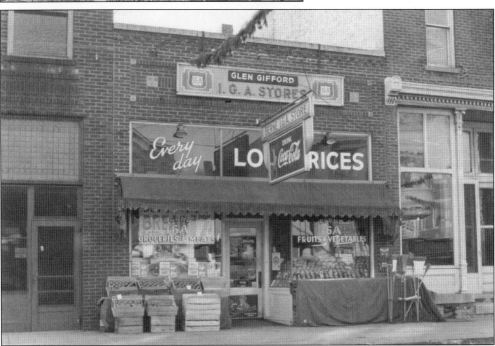

In 1938, Glen Gifford's IGA was established on the south side of Main Street and east of Jefferson Street. Like other grocers, he provided services unheard of today. You could phone in your order for free delivery. Or you could take him your list and he would fill it. For high shelves there was a long, hooked stick to pull off the boxes, which he would deftly catch—usually one-handed. Later the store was moved to U.S. 27 at the north edge of town.

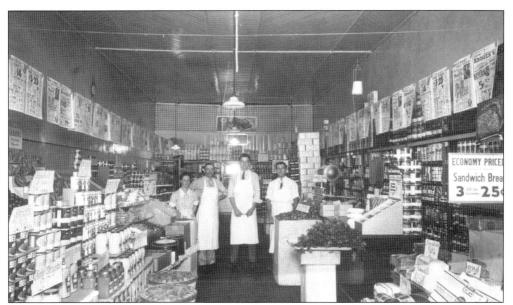

In 1925, the Kroger Grocery and Baking Company opened a store in Berne on West Main Street. The grocery was initially managed by William E. Stauffer, who seemed to know how to draw and hold trade. At a later time, with the grocery advertisements hung above the groceries, the workers pose for this picture. From left are Mary Jane Speicher, James Baumgartner, Robert Lehman, and Dan Speicher. The Kroger Store is well remembered at the location today of the Edelweiss.

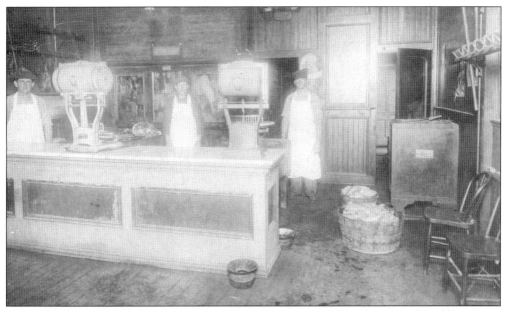

The Berne Meat Market, located just west of the First Bank of Berne, was purchased by Harvey Moser (left) and his brother-in-law, Edwin Neuenschwander (right). Cyrus Lehman (center) worked in the market after 1910. The slaughtering was done west of Berne. The meat market had a walk-in cooler to refrigerate the meat. In one of their advertisements we read, "During the warm days of the summer months it is especially important that meats be given the utmost in sanitary refrigeration to insure their reaching you in perfect condition. Satisfaction insured."

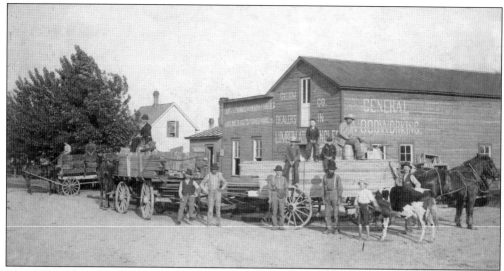

The Gilliom Lumber Company was the second lumber business to be established in Berne. The founder, Simon Gilliom, began his business on East Main Street. His son Austin Gilliom, 12 years old, is showing off his favorite cow. Also posing for the camera are farmers who had their lumber planed at Gilliom Lumber. The 1894 buildings are still used today by Amstutz Construction.

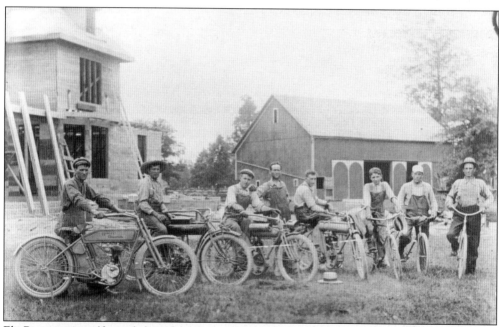

Eli Baumgartner (far right) and his construction crew members proudly display their two-wheelers. On the left is a 1912 Harley Davidson motorcycle. It had a battery ignition and four-horsepower motor with belt drive and sold for $200. It was nicknamed "The Silent Gray Fellow," because it was so quiet and dependable. It is also noteworthy that the only bike with a headlight is the third from the left.

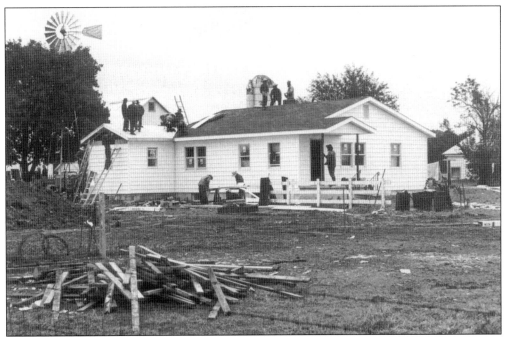

A most admirable occupation considered by many local Swiss, particularly the Amish, is carpentry, as this was also the craft that Jesus mastered. Amish crews work, not only locally, but also many carpenters commute from here to other communities in order to ply their trade in the construction business. Large vans provide transportation for the workers.

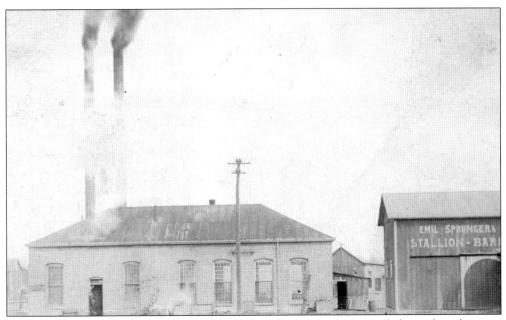

The Berne Electric Company produced electricity (1904–21) for the town's lights with coal energy, as shown by the roaring black smoke. To its east was a barn to segregate stallions from other horses driven to town. (Of interest is that a town ordinance prohibited stallions from participating in parades.) The buildings were located north of Water Street and east of Behring Street.

For more than 40 years, "Jess" Michaud was an auctioneer in this community. He got his start in the business with his father, Henry. His full name, Justin A. Michaud, was seldom used, as people knew him either as "Jess" or "Colonel." He was well respected and quickly became known for his auctioneering ability. He and his father both were able to speak Swiss, English, German, and French fluently.

This community has been fortunate to have many excellent auctioneers. Among others, there were Maynard "Miz" Lehman, Mel Liechty, and Phil Neuenschwander, all now at least partially retired. Phil taught many years at the Reppert Auctioneering School.

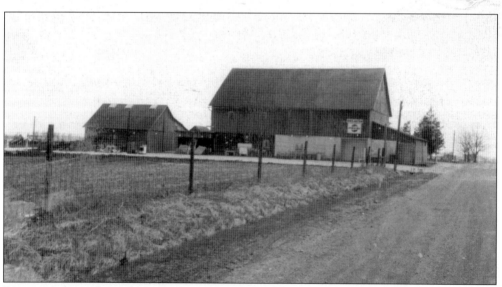

Emerson Lehman began his auction career in an old country schoolhouse. The school was sold within a year, and the auction house was established in the barn at Emie's residence. Following the destruction by the tornado of 1965, a new sale barn was built. Emie's Auction specialized in antiques.

Three
CALAMITIES

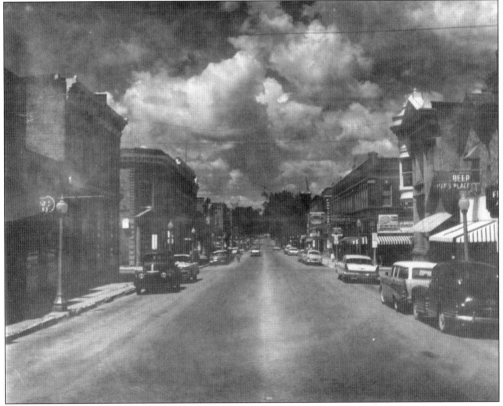

As the storm clouds gather and whirl over Main Street, we are all reminded of the devastation and destruction that has come to the Berne area. Flood, fire, tornadoes, murder, air disasters, and railroad and highway accidents all took a terrific toll on this community. The resilience of the people to endure catastrophic events has been, and still is, very evident.

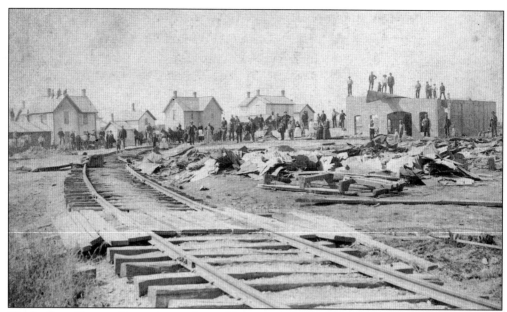

The Indiana Harrow Company was located between North Jefferson and Behring Streets where the Berne Furniture parking lot is today. This factory did not fare well as an enterprise, and trouble continued to plague them. On the night of September 12, 1888, the entire factory (stocked full of harrows), a sawmill, a planing mill, a flour mill, and a cane mill were completely destroyed by fire.

The Winchester Road (County Road 150 W) crossed the Wabash River over Price's Bridge. In 1900, the stack of Paul Gerber's "threshing machine" belched fire as he negotiated the steep ramp to the bridge from the east. Young John Burke, crew member, looked back after traveling a half-mile and saw the bridge being destroyed in an inferno of flames. Evidently, the many bird nests inside had caught fire.

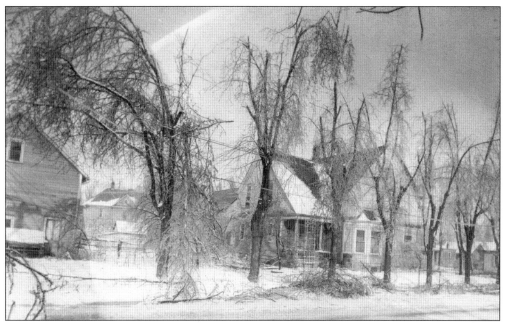

As most Midwestern towns know, there is a real danger in winter or early spring of an ice storm. Havoc and difficulty are caused so quickly as the limbs and trees are heavily laden with the coating of ice. When the wind picks up, the weight causes breakage of trees, shrubs, electric lines, and telephone wires. Following "God's pruning," there is much debris to be cleared away.

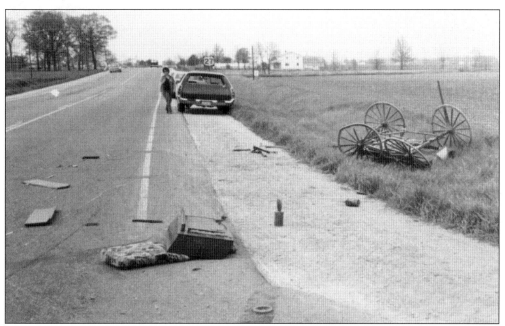

Unfortunately, there have been many auto-buggy accidents recorded in local history, and the injury, death, and damage toll is high. Motorists who are not familiar with the area and its high concentration of slow-moving, open, horse-drawn vehicles may come upon the buggies too fast to react evasively.

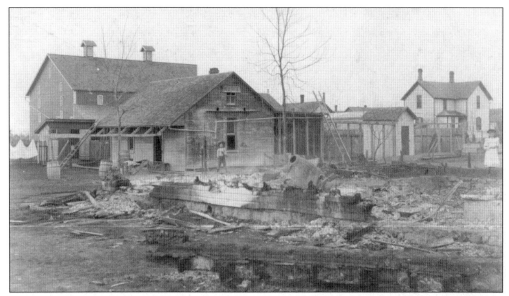

Rev. J.A. Sprunger's Light and Hope Orphanage at one time housed over 100 orphans ages one-and-a-half to 16 years in several buildings located two blocks north of Main Street on Sprunger Street. Shown here is the destruction of the girls' dormitory named "Jerusalem." The building was 54 feet wide and 98 feet long. It was all wood construction, so it burned very rapidly. This April 1899 fire resulted in the deaths of three orphan girls, ages 9, 14, and 15. Still standing in the photograph are the washhouse and barn.

The three girls who perished in the orphanage fire were Mamie Broderick (top left), Della Taylor (top right), and Katy Goebelbacker (not identified). The deaconess is recognized by the symbolic large white bow at the neckline of her dress. The variety shown in the girls' dress collars may suggest efforts to distinguish age or number of years in the orphanage.

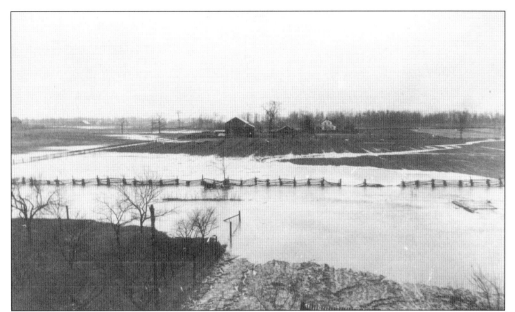

The flood of 1913 ravished our community, as it did much of the Midwest. Old timers claim that the waters actually crossed the Eastern Continental Divide in the vicinity of the Canoper School (located at county roads 700S and 000). In Berne, storm drains under the railroad bed were most inadequate, causing such flooding on Water and Behring Streets that the water level was above the main floors of many residences.

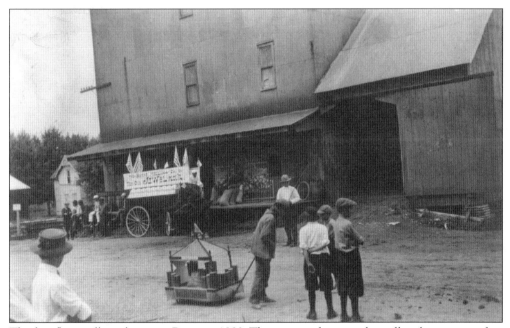

The first flour mill was begun in Berne in 1880. The greatest threat to the milling business was fire. From 1880 until 1924, when the milling business was discontinued, there were three major fires that destroyed the mills. The last mill was this four-story wooden structure known as The Berne Milling Company. Preparations had been made for the Harvest Day Parade in August of 1914.

Anthony "Tone" Michaud, age 69, was working at Moran's grocery when, at 6:00 a.m. on Monday, August 28, 1939, two non-local men pulled up to the gas pumps. After Tone filled their tank, they shot him twice, and moments later he died. Mrs. Sam Schindler heard the shots and looked out her upstairs window. Briefly her eyes met those of the gunman who then quickly sped away. It seemed the crime had no clues to follow. Then three months later, while reading a newspaper, Mrs. Schindler spotted a picture of the gunman being held by the Chicago police for a murder there. She instantly recognized him as the murderer of Tone. The murder scene was 163 North Behring Street, which is the present Farm and Home Center.

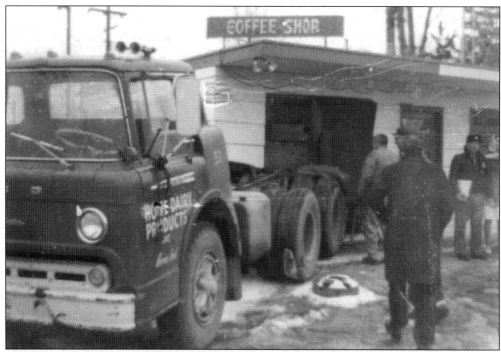

Miracles do happen. A Home Dairy truck being towed south past the school on U.S. 27 broke loose as it approached the usually busy intersection at Main Street. As it veered to the west, no students were at the crossing, and no cars were waiting for the light. But a parked car was then thrown aside, and a concrete post was hurtled into the east bar stools of the coffee shop, followed by the run-away vehicle, now on its last gasp. No one was badly hurt as customers were on the west bar stools, and incoming Clarence "Moosic" Sprunger managed to dodge the oncoming projectiles.

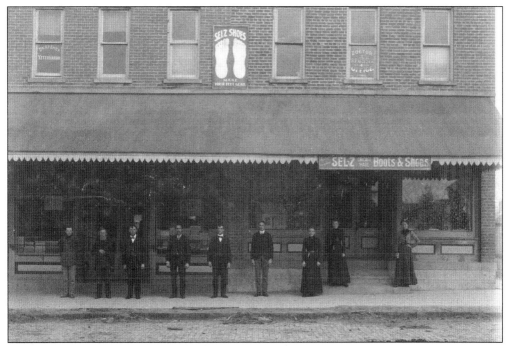

Shown is the Sprunger and Lehman Department Store and its employees. The right half of the building was the first brick store in Berne (1881), and subsequently, another 110 feet were added to the west. This was "The Champion Block," which went up in flames in 1918. Note the offices of Doctors Reusser and Emick on the second floor. It was common for the offices of professionals to be located above stores.

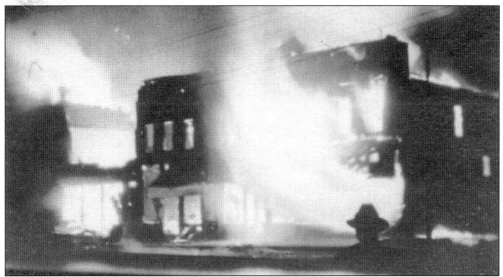

The Champion Block fire in 1918 was, historically, Berne's worst. Even with hundreds of volunteers, it was a losing battle. For water, there was the cistern in the middle of Main and Jefferson. For equipment, there were only hand pumps to feed hoses. For volunteers, there were hundreds, but all were helpless. The tally: one person dead and three businesses destroyed on Main Street. A modern, pressurized water system was soon underway.

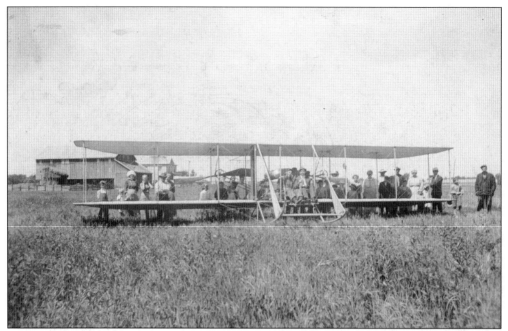

As far back as 1919, airplanes came to Berne to give rides to the people of the community. The airstrip was in a field on the John Lehman farm north of town. The two pilots promised a safe and sane ride to the public. The tickets sold for $10 for a straight flight and $25 for a stunt flight. Over the years there were several landing fields, and this popular thrill became a yearly event.

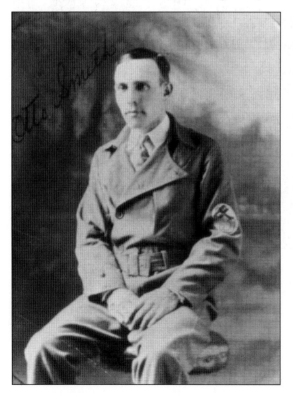

Unfortunately, accidents occurred. Probably the largest funeral ever held in Berne was for Otto C. Smith, age 33. He was a stunt flier who did "the loop" too close to the ground at the Montpelier, Indiana, racetrack. On August 31, 1927, stores were closed and flags were at half-mast. Hundreds, who found the large Mennonite church already filled to capacity, proceeded on to the M.R.E. Cemetery. Professor C.O. Lehman sang "Jesus Savior Pilot Me" at the funeral service. At the grave site interment, when the body was being lowered, flowers from the lead plane of a flight formation were dropped as the other planes dipped their wings in final salute. The estimated crowd was 3,000.

Fourteen years later, his son, Otto Jr., age 23, also died in a plane crash. He was flying to the Mennis Wulliman farm to give his son "Herb," a friend of Otto, a ride. Apparently, he was unaware of his proximity to utility lines and stalled his engine in attempting to avoid them.

PAUL ROHRER

(A Martyr to His Cause)

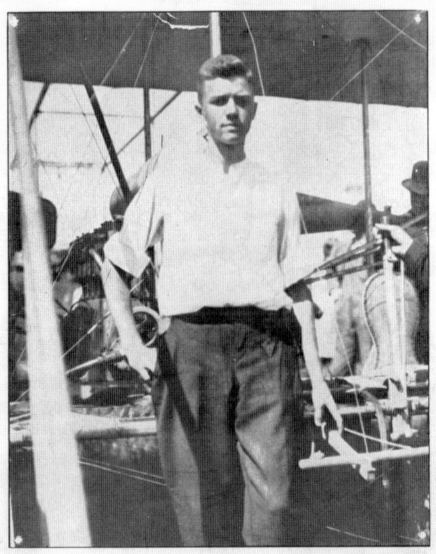

Plunged to death when he was just about to make landing with airplane of his own design and make, on Thanksgiving, November 30, 1916, at 5 P. M. after making perfect flight over Berne, Ind. and vicinity, passing over his home twice at an altitude of about 1500 feet, covering a distance of about 30 miles in 30 minutes. Age 19 years, 4 months and 26 days.

He builds too low who builds below the skies. Not ours to reason why; ours but to dare and die.

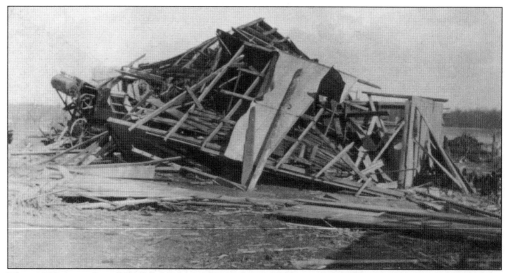

This 1920 tornado saddened the entire community. There was much more devastation than the county had previously experienced. Three were killed in Wabash Township, and two were killed in Jefferson Township. The barn at the Howard Parr farm was completely destroyed. At other places, decayed shingles were found securely wedged in green timber and pieces of cloth tightly woven among the branches of trees.

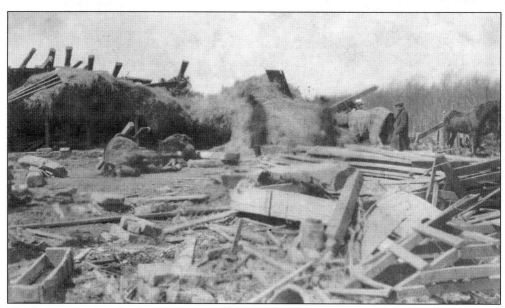

The huge timbers of this barn were tossed like toothpicks in an instant of time. The loose hay in the mow dropped. Two horses in the center had been in their stalls along with the horses on the right. How some were uninjured and others killed instantly is hard to imagine.

On Easter Sunday 1964, firemen raced out of church services and reached the fire scene in less than three minutes—but it was too late. Destroyed, on the north side of Main Street, were Stuckey's Department, 5¢ to $1 Store, and Mennonite Book store. The latter two were rebuilt. Seven persons who occupied second-story apartments were made homeless temporarily.

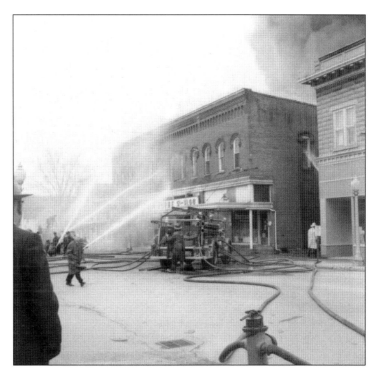

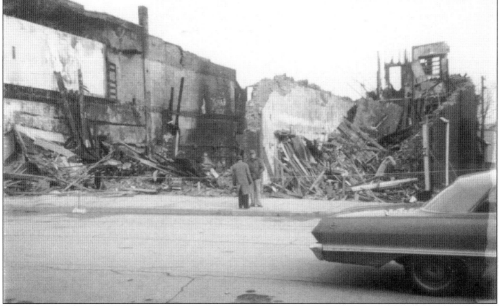

Behind the car are the remains of the Mennonite Book Concern following the Easter Sunday fire. Following the fire, the book store was rebuilt. The early days of the company had been filled with many opportunities in printing. The *Kinderbote* was a children's religious paper printed in German. Often in the evening, the mothers would read aloud to the children while they worked in the kitchen. The company had also printed books and hymnals for the churches. Today the Provident Book Store no longer does any printing, but the store is one of the best religious bookstores in the entire area.

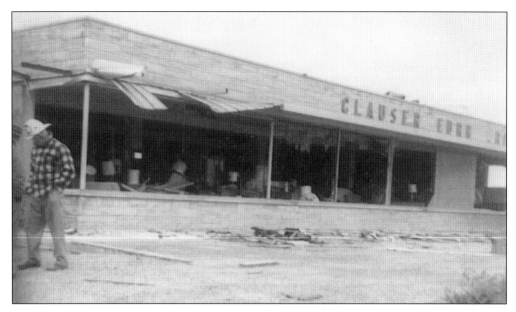

Within two hours after the devastating 1965 Palm Sunday tornado hit, Adams County Red Cross Volunteers had opened a canteen, first aid station, and a command center for local, county, and state police in the Berne Library. Soon, the National Guard was also on site. As operations grew, the disaster headquarters shifted to the Mennonite church, where clothing was collected and volunteers prepared meals. In addition to guarding many unsecured sites, the National Guard also operated a field kitchen in Linn Grove. The community was widely lauded for its quick and humanitarian response. The interior of Clauser's showroom was complete devastation.

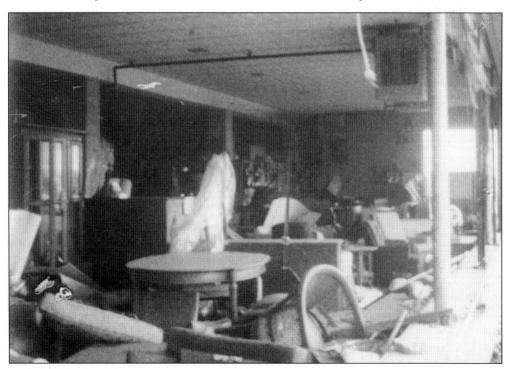

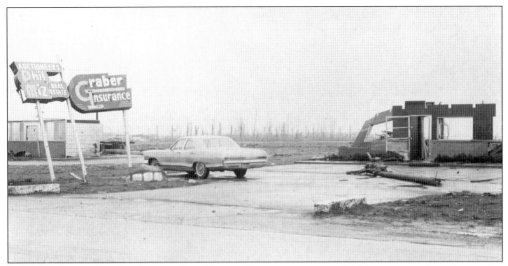

Time after time, families have suffered losses. Sometimes it was the home, sometimes it was the family, and sometimes it was the business that was tragically ruined or destroyed. In the 1965 tornado, some lost both their home and business. It is a real calamity that some have endured these disasters more than once. But the people have rallied to give assistance and encouragement by giving a helping hand to ease the burden. This attitude is a distinguishing mark of the Swiss community.

When the word "tornado" is used in this community, one's mind flashes to the Palm Sunday Tornado of 1965. The toll of this major storm, according to the Red Cross report, was:

Persons
 Dead—2
 Hospitalized—36
 Injured—100
Dwellings
 Destroyed—59
 Major Damage—41
Trailers
 Destroyed—12
 Major Damage—5
Farm Buildings
 Destroyed—172
 Major Damage—28
Businesses Destroyed
 Emick's Bowling Alley
 Poplar Drive-In
 Habegger Builders Supply
 Graber Insurance Agency
 Phil & Miz Auction Co.
 Honda Motor Cycle Sales
 Globe Hatchery
 Berne Hi-Way Hatchery
 Culligan Water Conditioning—Linn Grove
 Meshberger Stone Corp. Warehouse
Industry Heavily Damaged
 McIntosh Inc.

Businesses Heavily Damaged
 Clauser Furniture Store
 IGA Super Market
 Parr's Tire & Implement
 Phillips 66 Station
 Flick's Body Shop
 Lehman Feed Mill
 Linn Grove Hardware
 Berne Equity—Linn Grove
 Paul Yoder Garage—Linn Grove
Schools Damaged
 Berne High School Athletic Field
 Berne High School Shop Building
 School Buses—three
Churches Destroyed
 Evangelical United Brethren—Linn Grove
 Linn Grove United Church of Christ
Recreation Facilities
 Pine Lake—destroyed
 Linn Grove Playground—major
 damage
Utilities
 Indiana & Michigan Electric Co.,
 ($1,000,000)
 Citizens telephone Co. (no estimate)

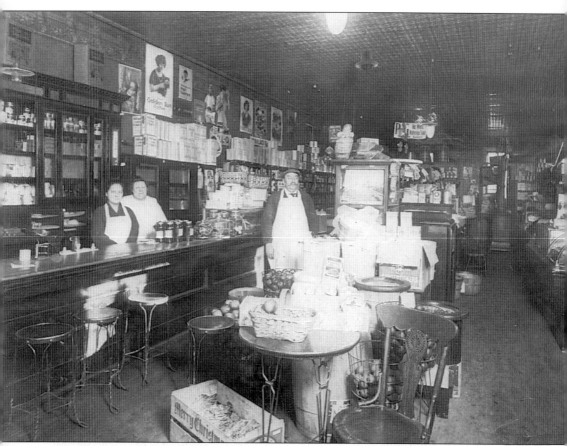

This old frame school building had been located at the northwest corner of Water and Jefferson Streets. In 1908, it was moved to 155 North Jefferson to permit construction of the First Missionary Church. Innumerable shops were housed in this building over the years.

From 1919–38, the A.J. Myers family ran a unique grocery store in Berne. "Andy" was most innovative, and his shop may have been a forerunner of the modern super market. He sold most anything, including dry goods, varieties, sodas, and pop. Affable Andy's favorite role was to use his natural knack to make ice cream sodas while chatting with the customer.

Mike Zehr's print shop was the last business in this building. He lost his life in a gas explosion in 1990, which completely destroyed the building.

Four
CHURCH INFLUENCE AND ACTIVITY

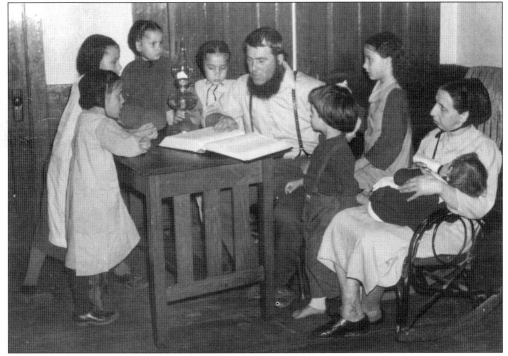

The strength of the family and a community comes from the roots of faith and belief. The entire family was a close-knit unit. Each evening was family worship—*Andacht*. In the early years, prayer in Swiss followed the Bible reading in German. All the family members were attentive to the family devotions.

The four original churches of the Swiss community—Amish, Apostolic Christian, Mennonite, and Reformed—have been included in this section. In addition, there were two nationally recognized denominations that began here. The Evangelical Mennonite Church was started in 1865, and the Missionary Church in 1898. The influence and benefit of all the other churches is in no way minimized in this historical presentation.

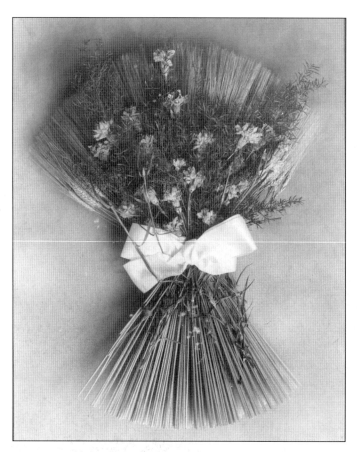

Sheaves of bearded wheat were common symbols of death in the early 1900s. Appearing in the beds of coffins or being hung on doors, they were symbols of Christian death. The Stucky/Lehman family has a plain sheaf of wheat that was used within the family. From 1913 to 2000, this sheaf has been used 23 times for family members. (Photograph by Shalley.)

The Sheaf of Wheat. . . Symbol of Christian Faith

The seeds of faith are sown in the human personality
and grow into the mature faith of the
Christian man or woman.
The sown seed must lose its life in order that
it may develop and grow and multiply.
So symbolically, a sheaf of wheat is used by
Christians to mark the passing of a fellow Christian.

Death is not the end
but the beginning of life eternal.

The mature grain in the sheaf is the direct symbol of the
Resurrection—the life beyond the grave,
the fulfillment of the promises
of Jesus Christ.

68

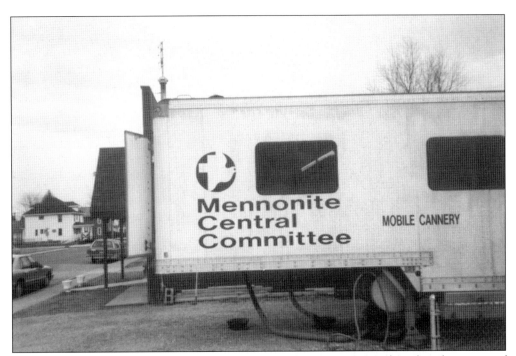

"I was hungry and you gave me something to eat," Matthew 25:35. Heeding the admonition of Christ, the church community takes to heart the directive to feed the less fortunate.

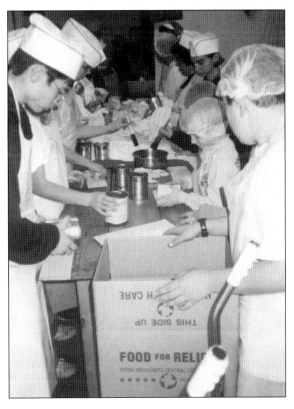

Initially, the project was begun after World War II by some Mennonite women who canned food in glass jars. The Mobile Cannery unit of the Mennonite Central Committee houses the canners that make this project possible. The canning project sponsored by the First Mennonite and Apostolic Christian Churches has been an annual event for over 40 years. The Berne Locker donates its facilities; the money to purchase beef, chicken, and cans comes from other individuals and churches. Volunteers do all of the processing. Fifteen tons of food are distributed annually to the hungry both in the United States and foreign countries.

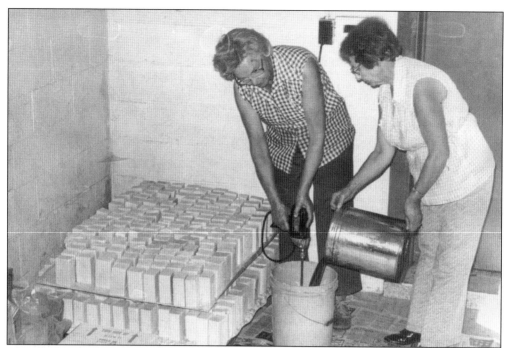

In early days, soap was made from pig lard and wood ashes, of which there was plenty. About 1970, Naomi Von Gunton and her sister Laura Kirchhofer had an idea. They would make soap and have the MCC distribute it to the poor overseas. It worked. They collected used grease at restaurants and instead of ashes, bought lye in 50-gallon drums. Volunteers helped with the project, and literally tons of soap were made by 1983, when they lost use of their workspace. Some members of the Apostolic Christian Church then took over.

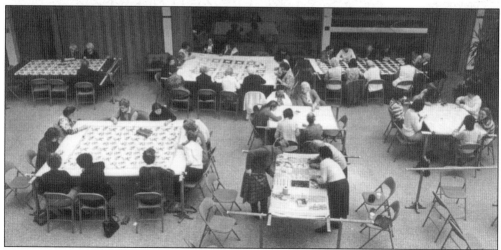

The ladies of the First Mennonite Church have quiltings twice a year in addition to monthly meetings. Each quilting is at least one week in length. During these times, quilts, comforters, and wall hangings are prepared for the yearly Relief Sale sponsored by all the churches of the district. The funds gained from this sale are used to help in disaster relief programs of the denomination. Often ladies from the Apostolic Christian Church and the Evangelical Mennonite Church of our area come for a few days of quilting.

70

This Sesquicentennial Quilt was made in preparation for the celebration of the 150 years of the Mennonite Church in Adams County. It was designed by Roger L. and Verna Sprunger, appliquéd by Mrs. Jeff (Becky) Lehman, and quilted by the ladies of the First Mennonite Church.

This quilt was on exhibit in Bern, Switzerland, during a number of months in 1991, which marked the 700th anniversary of the founding of Switzerland. The Swiss government requested an exhibit for the celebration and furnished (via Swiss Air) transportation for the loaned quilt. (Photograph by Steve Hult.)

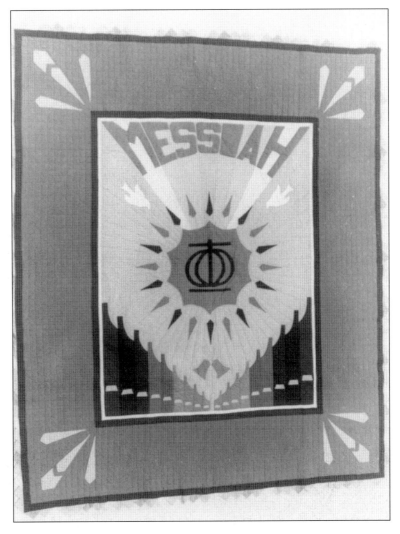

Each symbol is identifiable as:

Messiah represents Christ and is also the name of the oratorio given since 1891. The seven letters in the word "Messiah" represent the church's seven choirs.
SS letters in "Messiah" represent the Sunday School.
The two doves represent the Mennonite position on peace.
At the center is the emblem representing the Mennonite General Conference.
Surrounding the center is a 10-point circle representing the 10 pastors who had served the First Mennonite Church as of that time.
The 20 diamonds outside the circle represent the 20 countries served by our missionaries.
The two bells represent the Hand Bell Choir and the organ chimes.
The organ pipes at the bottom represent the 2,281 pipes of the organ.
The 16 diamonds on the four corners represent the 16 conferences that have been held in the church.
Surrounding the quilt are 150 edging points representing the 150 years of existence—1838–1988.

Amish church congregations worship in each other's homes on Sunday mornings rather than in a church building. A large, black, frame-enclosed wagon is used to transport backless church pews to the farmstead that is next scheduled to hold services. (Photograph by Steve Hult.)

Der Ausbund, the early hymn book without notes, dates back to 1564 during some of the darkest days of The Reformation. It contained many hymns filled with a touching depth of faith and martyr ballads that breathe an atmosphere of readiness to die. Prisoners and others who had suffered religious persecutions wrote many of the hymns. At least 130 of these writers are known. Of the several local Swiss churches that once used this hymnal, today only the Amish churches do so. (Photograph by Steve Hult.)

72

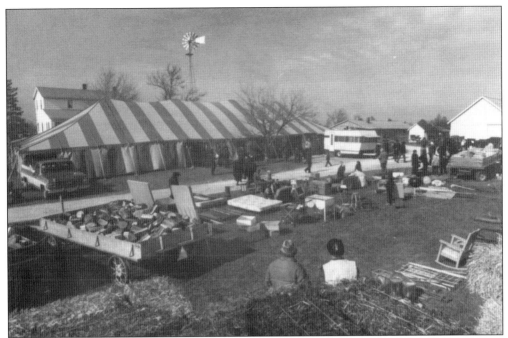

Since the Amish do not participate in any health insurance programs, the families pay their hospital and doctor bills. From time to time, there will be a benefit sale to help a particular family financially. For sale there may be wagon loads of baled hay, cut firewood, furniture, tools, quilts, and items for the home. Usually there is also a home-cooked dinner provided for a donation. The community generously supports these benefits.

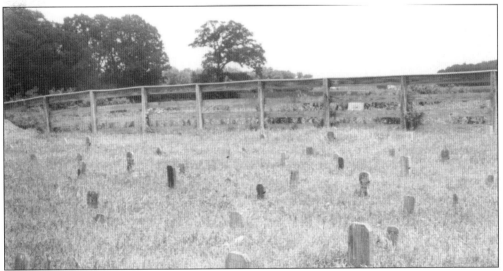

An Amish cemetery is arranged somewhat differently than most others. Amish cemeteries traditionally have been arranged according to the sequence of death rather than in family plots. (In some areas, spaces are now being saved for spouses.) Through the years, most of the grave markers were small wooden stakes with the initials of the deceased carved in. While this is sometimes in use today, more and more stones with engraved names or initials are commonly found. (Photograph by Steve Hult.)

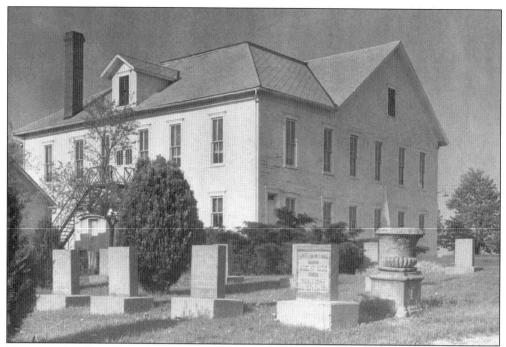

Shown is the Apostolic Christian Church as it appeared sometime after 1947. A new brick church was constructed at the same location in 1950, with a seating capacity of 1,500. The congregation was founded in 1858 by preachers Ulrich Kipfer and Matthias Strahm, who came here with a group from Switzerland in 1852. The church is located on the Adams-Wells county line road at County Road 200 S.

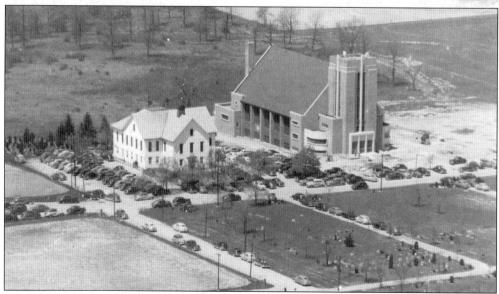

The large, new, country Apostolic Christian Church, dedicated in 1950, was the third sanctuary for the growing congregation, which had their first baptisms in 1858, and built their first sanctuary in 1867. Each Sunday noon, the congregation enjoys a fellowship meal. A host family registers for each week. Host families serve on approximately a four and one-half year rotation.

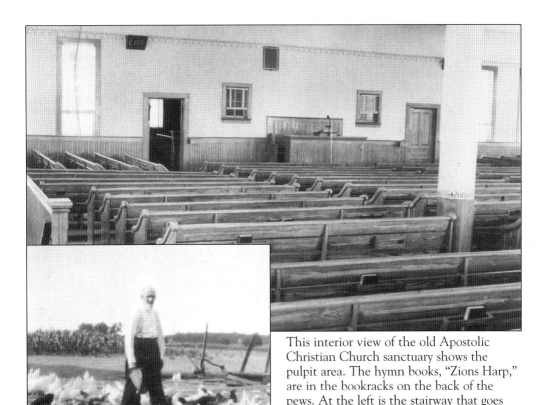

This interior view of the old Apostolic Christian Church sanctuary shows the pulpit area. The hymn books, "Zions Harp," are in the bookracks on the back of the pews. At the left is the stairway that goes down to the fellowship area.

Daniel Gerber, above, who was added to the Apostolic Christian Church ministry in 1903, was the first resident minister to preach in English instead of the traditional German language. This change occurred in 1921. Gerber, a farmer by occupation, is seen tending his chickens.

Godfrey Rauch was the second resident elder of the Bluffton Apostolic Christian Church. Rauch was selected to the ministry in 1898, and was ordained as elder in 1913. His predecessor was Adam Hartman.

Samuel Aeschliman, pictured right, was the third resident elder of the Bluffton Apostolic Christian Church. He was added to the ministry in 1936, and was ordained as elder in 1941. He served until 1975.

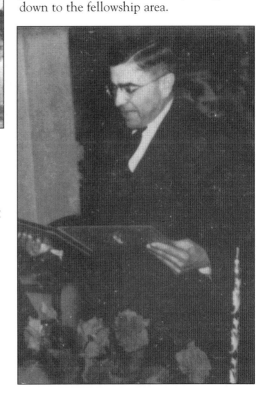

This church was built about 1860 in French Township by the first Mennonite congregation established in Indiana prior to the 1852 Swiss migration. Deacon David Baumgartner founded the fellowship, and it was thus known as the "Baumgartner Church." After four moves, the restored historic building is now located at the Swiss Heritage outdoor museum on the north edge of Berne. (Photograph by Steve Hult.)

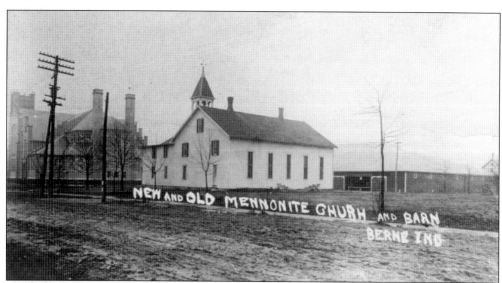

In 1852, a Mennonite church group from Switzerland settled here and met in each other's homes until they built a church in 1856. This 1899 building had a seating capacity of 1,500 people. The large barn of 95 stalls was erected in 1910, to provide shelter for the horses. The farmers drew numbers for their stalls, and they could purchase a stall for $38 or pay rent at $4 per year. Later, for a period of time, the barn was used for cars. On Good Friday, just prior to the dedication service on Easter Sunday, April 7, 1912, the church conducted a very meaningful farewell service in the old church.

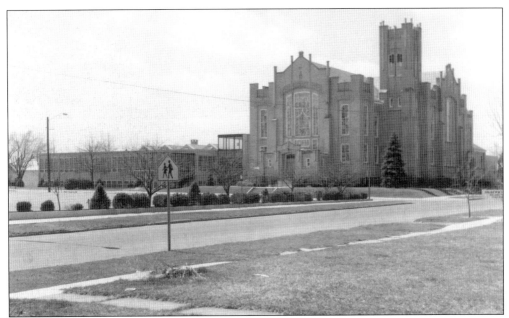

The present Mennonite church building is a modified Gothic style. The sanctuary, seating 2,000, was dedicated in 1912. This dedication drew three special trains of interested persons. The 1959 educational unit, shown at the left, provides classrooms, a chapel, a fellowship hall, and office space.

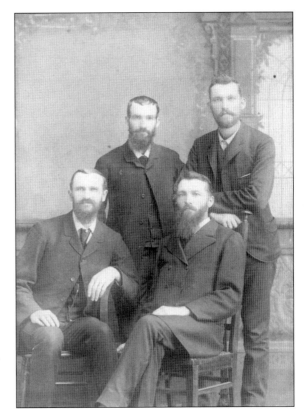

Each of these four men was a leader in the Mennonite Church. Rev. I.A. Sommer (left) and J.F. Lehman are standing. Rev. S.F. Sprunger, pastor of the First Mennonite, is seated on the right. These men gave a unified voice of true leadership. They were committed to God in thought, word, and action. They possessed the ability to look beyond the obvious to gain insight from God. (Photograph by Leisenrings of Mt. Pleasant, Iowa.)

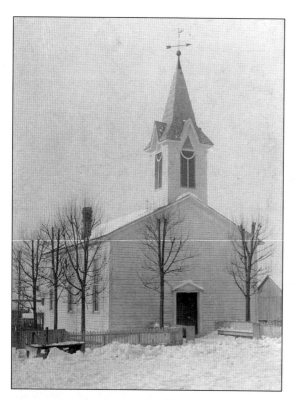

The German Reformed congregation of Vera Cruz built a church in 1858 to serve the people of French Township and the surrounding areas. This church building served the worshippers for 53 years. At the top of the church steeple was a copper rooster, which, as in Switzerland, indicated a Protestant church. (A cross on the steeple indicated a Catholic church.) The gifted coppersmith was Benjamin Beer, a grandson of Deacon David Baumgartner. The Vera Cruz church is considered by many to be the mother church of Cross Church of Berne and the UCC Church at Magley.

St. John's Reformed Church in Newville (now Vera Cruz) started the first cemetery in the new Swiss colony about 1850. The graveyard is located on the west side of the Adams-Wells county line road a short distance north of County Road 200 S. Its setting is on a beautiful knoll, which overlooks a small picturesque stream. The church would graciously accept burials from other Swiss denominations. A blend of the faiths—Apostolic, Mennonite, and Reformed—are buried here.

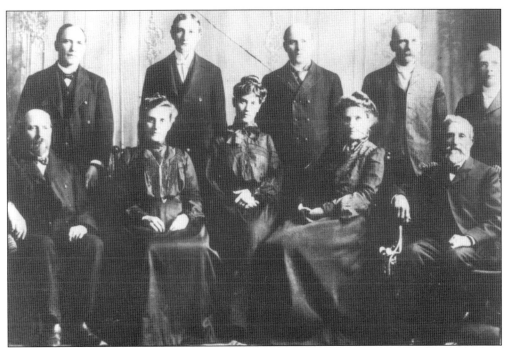

The Rev. Peter Vitz family played a prominent role in establishing the St. John's German Reformed Church in Adams County in 1849. He established churches in Honduras, Magley, and Vera Cruz. Five of his sons became active in the Vera Cruz congregation, and two of the daughters became wives of ministers.

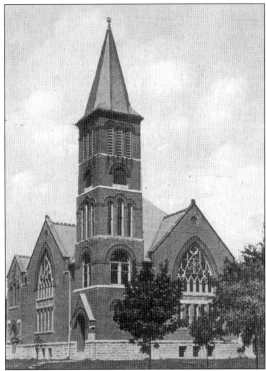

Cross Reformed Church was organized in 1869, and the next year they built a church on the west side of the old Winchester Road (County Road 150 W) near present day County Road 850 S. In 1896, the growing congregation built this beautiful new sanctuary in Berne, and after a farewell service in 1919, the old church was moved a few miles north of Berne.

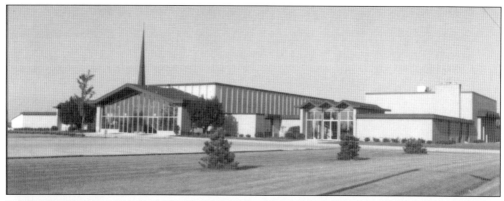

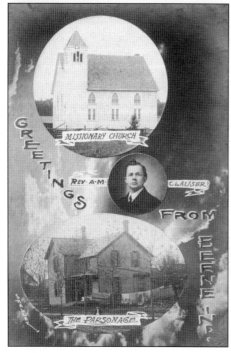

Top: First Missionary Church was begun in 1893, by Rev. and Mrs. J.A. Sprunger and friends in connection with the Light and Hope Orphanage. In 1898, the church joined in the founding of the Missionary Church Association (now Missionary Church, Inc.). In 1908, they built on the corner of Water and Jefferson (Berne Antique Mall), and in 1960 moved to their present site at 950 U.S. 27 South.

Middle: The Defenseless Mennonite Church pictured below was formed in 1865 by Henry Egly, a bishop in the Old Order Amish Mennonites. The name has been changed to the Evangelical Mennonite Church. Subsequently, this church has led in the founding of a new denomination.

Left: The West Missionary Church began in 1898. At that time it was called the Linn Grove Missionary Church and had 71 members. After several building projects, the congregation now has adequate facilities for the increased membership.

80

Five

FARM LIFE

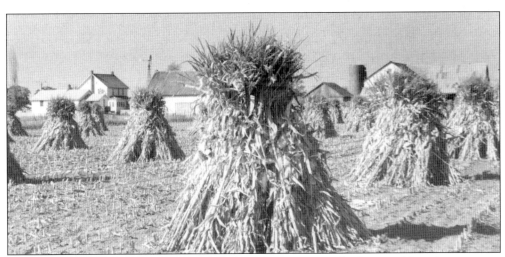

Shocking was both a skill and an art. Some used foot cutters, and others used long knives to cut corn stalks, which then were then stood on end inside a circle of uncut ones. These were then all tied together with a single stalk to secure the plants from falling down. After drying, the corn was husked and the shocks stored for animal bedding. An excellent worker's accomplishment was about 100 shocks a day.

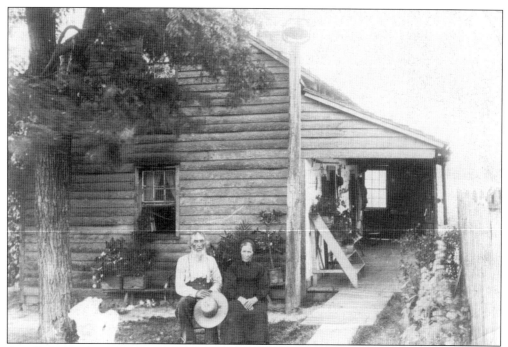

A well-deserved rest is taken on this early summer afternoon as Philip and Mary Hirschy enjoy the breeze. The flowers are in bloom, and the fresh air comes into the open windows. This home was built in 1848, after he took claim of the 160 acres in 1847, for a total purchase price of $550. The farm homestead is 1 mile south of Berne.

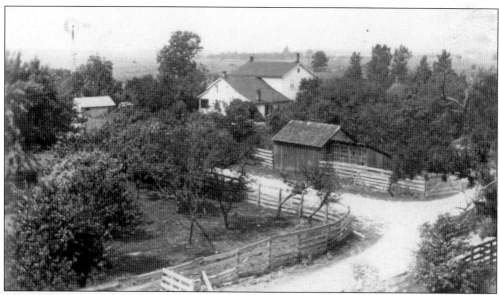

The farm homestead of Philip and Mary Hirschy helped to make a family self-sufficient. To the left of the lane, a large orchard of pears, apples, cherries, mulberries, and peaches was well cared for. The small hen house just inside the wooden fence along the lane had many windows to allow for maximum light for the chickens. The large farmhouse, built in the early 1890s, provided ample space for family and for entertaining. The house is still standing.

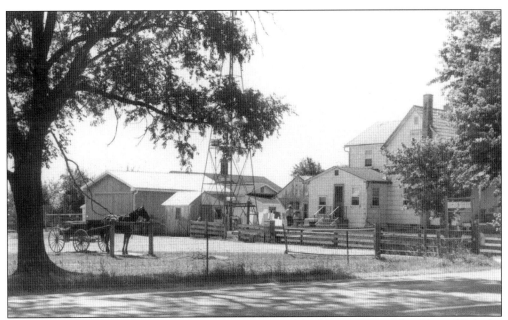

At first, while forests were being cleared, the farmstead buildings were made of logs. With the coming of the railroad, large equipment, such as steam driven band saws, were brought in and frame wooden structures began emerging. The local countryside still reflects this era, which is portrayed by the many pristine Amish farms still in existence. (Photograph by Steve Hult.)

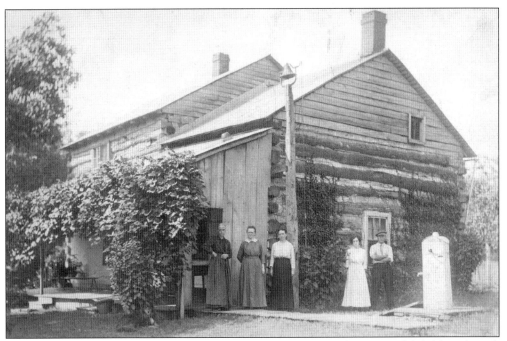

Most farm homes had a dinner bell to call the family for a meal. As one did field work with horses or worked in the orchard or garden, it was a wonderful sound to hear the bell. Frequently, more than one generation lived in the same family home. The cistern pump was conveniently placed for the family.

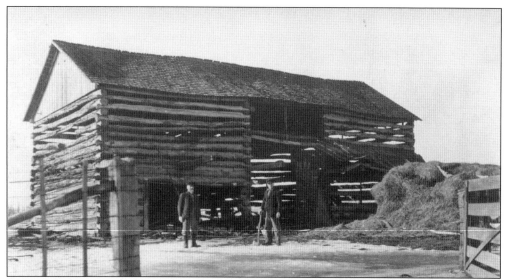

The crib barn was primarily designed to store hay and grain. It appears that in the lower left, the hewn hardwood logs were chinked with clay, possibly to shelter animals. The wet clay was layered with straw. Farmers would lead oxen or horses back and forth over the mixture in a kneading motion to blend the clay and straw to the right consistency.

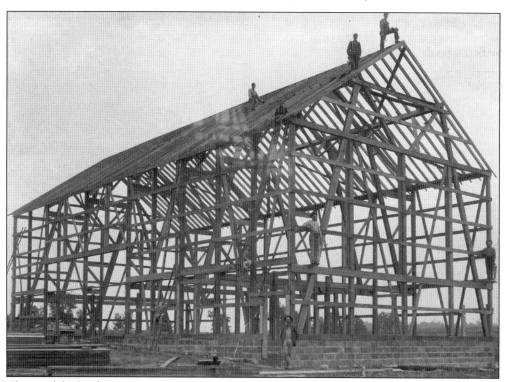

The need for big barns came about after most of the forest was cleared and special shelter was needed for horses and milk herds, along with their feed. Heavy log timbers were replaced with uniformly sawed framing material as large, steam-powered wood saws became available. Also available after the coming of the train in 1872, were sheets of corrugated tin for roofing.

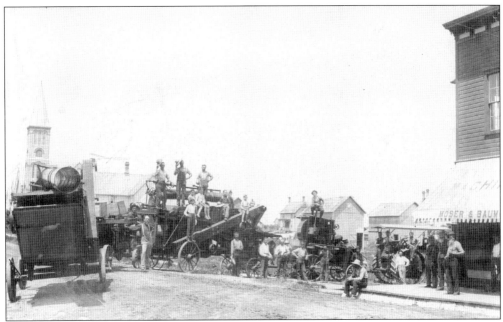

In 1895, A.J. Moser and John P. Baumgartner opened a repair shop for threshing machines. For several years as a young man, Abe had been a professional thresher, and he was aware of the mechanical problems faced by the threshing gangs. Rather than having to send away for every repair part, Abe developed a way to repair locally and save time for his customers. (Photograph by Berne Studio.)

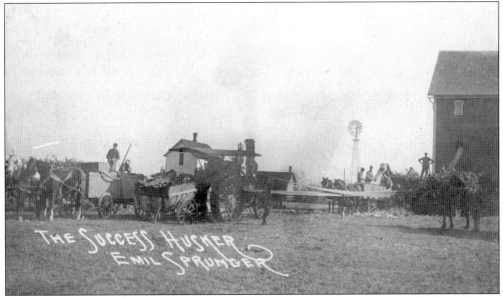

Threshing crews or rings with machinery powered by huge steam engines were common during the early 1900s. The owner would secure workers for the season and travel from farm to farm. The farmers had their grain in shocks, and if they were late on the list of customers, they frequently hauled the dry shocks into the barn to keep them dry until the threshing ring got to them. Emil Sprunger, the head of this ring, worked especially in the north and eastern outskirts of Berne.

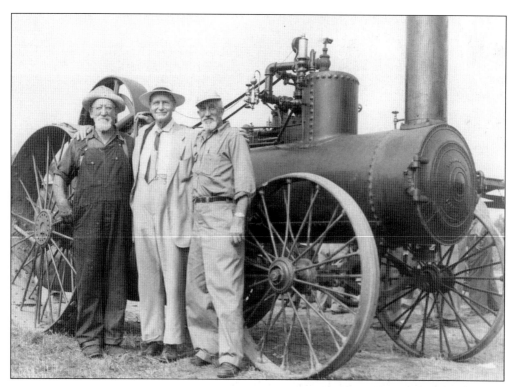

The giant steam engine provided power for threshing and filling silos on many area farms. Standing in front of this restored "power house" at the 1952 Berne Centennial, from left to right, are: Benhart Lehman, Hubert P. Schwartz of Decatur, and Wilbur E. Lehman. A steam engine supplied the power for the threshing machine, below, which separated the grain from the straw. Today, many Amish still use this method of harvesting wheat and oats.

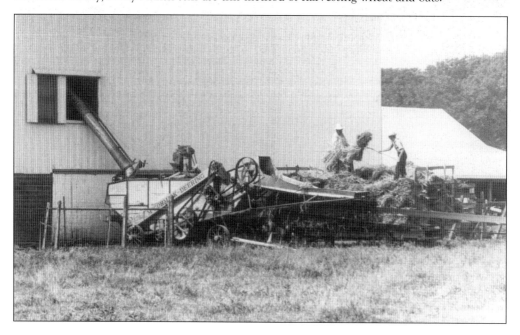

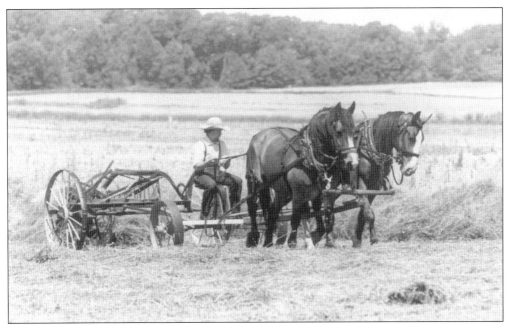

In the midst of a progressive community, one can still see the use of farming techniques and equipment of a bygone era. The hay is cut, left to dry for a couple of days (depending on the weather), raked into windrows, then loaded on a wagon and taken to the barn for storage. For good fieldwork, each driver must be familiar with the team of horses.

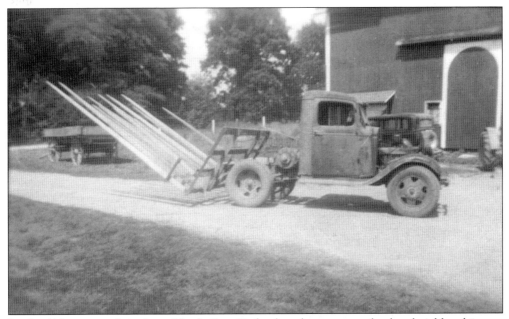

In the '40s, young farm boys like LeRoy Yoder loved to operate buck rakes like this one converted from a 1935 Chevy truck. The pronged rake would be lowered to the ground and the truck backed to pick up cured hay lying in the field. After raising the loaded hay, the truck would unload it on a sling lying on the barn floor, which would then be hoisted up and the hay dropped into the mow.

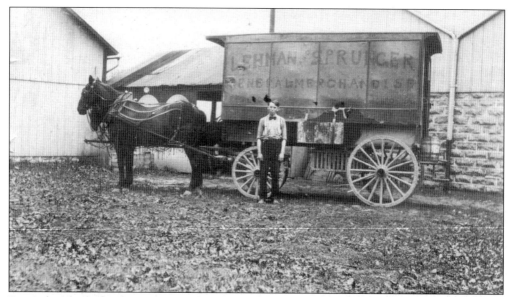

Posing beside the huckster wagon (about 1913) is Manas Lehman, who was a partner of Robert Sprunger in the Lehman and Sprunger grocery business in neighboring Monroe. The men ran regular country routes to barter with farm wives who traded eggs, butter, and chickens for groceries not readily produced on the farm. When Lehman went into the hardware business, Sprunger renamed his business the Dutch Store.

The cage was not for a ferocious animal but for elusive poultry. The girls have a job to do. Some barnyard roosters may be destined for Sunday dinner, or some chickens from the coop will be bartered when Dad goes to town. The fun will be catching them. One thing is for sure—when they're snared with the wire leg hook, the feathers will fly.

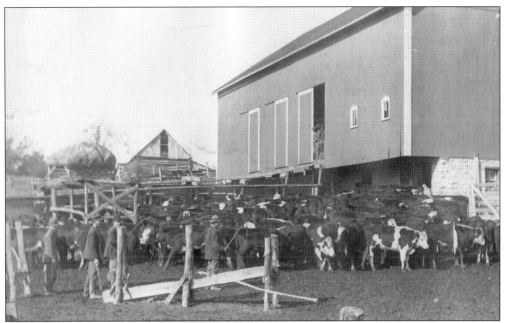

Josiah Crawford, from Pennsylvania, settled on the Swiss colony's eastern edge in 1839. As a cattle merchant, he brought in large herds from Darke County, Ohio, primarily for resale to drovers. He helped many local Swiss settlers get started with their herds and supplied them with preferred shorthorns. In turn, he borrowed from their European dairy barn concepts by erecting the "Swiss" barn, which still stands at 6306 S on 200 E.

The production of honey has been an important aspect of the farming community. In many homes, a square honeycomb was frequently on the table. Extracted honey was used in many recipes, which was especially helpful during the days of the rationing of sugar. Beekeeping was a very real part of farm life.

Drying, along with canning, was a primary way of preserving fruits and vegetables grown on the farm. As shown, the wire-mesh pullout drawers had solid wood fronts to seal off the inside heat generated by a kerosene stove. Dryers, brick bake ovens, and water-heating facilities were often outside so as to keep the buildings reasonably cool inside during the warm months.

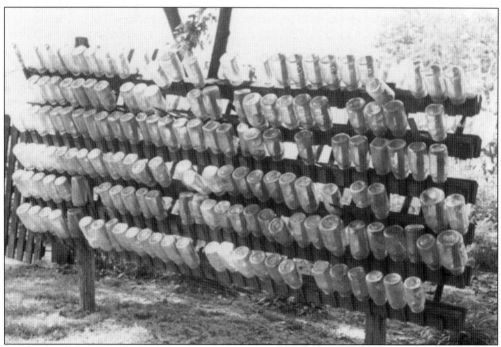

When the glass industry boomed in a neighboring area, canning became the main method of preserving food. Empty jars were washed and then placed on outside racks for easy storage and sterilization by the sun. The jar racks are still a common sight on local Amish farms, as much of the produce from their large gardens is still canned.

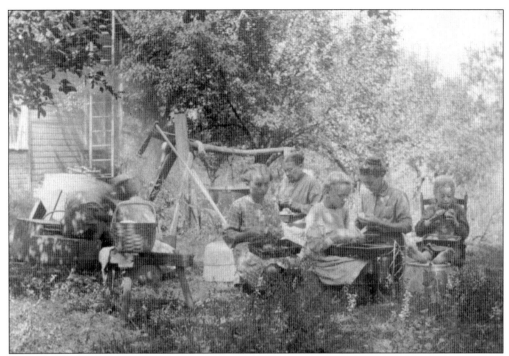

Even the young among the pioneers helped with the "schnitzing" (peeling) of apples. After sorting out the best ones for eating, the rest were graded and then pared for pies, canning, and apple butter. The remainder was then pressed for apple juice, cider, or vinegar. The peelings and bad apples would end up as feed for the pigs. There was absolutely no waste. Three generations work together, as they teach domestic skills at an early age.

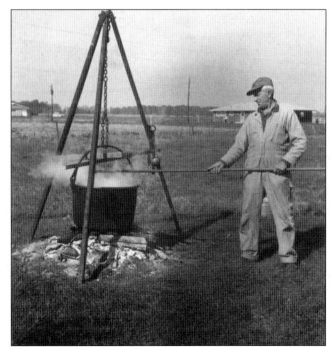

The fall season is apple butter making time. Years ago this was a familiar scene. Fresh apple cider was brought to a boil, and apple "schnitzes" (peeled and sliced raw apples) were added. The mixture was cooked for several hours and stirred constantly. Sugar and spices were added as needed. Usually a batch of 10 or 12 gallons was made in a day.

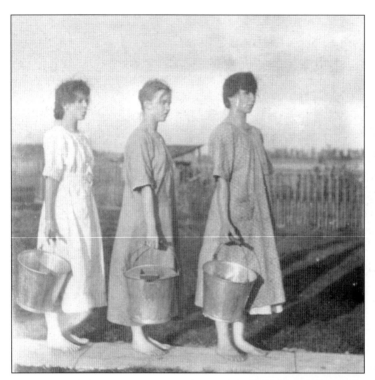

The three barefoot sisters with milk pails in hand are on their way to the barn to milk the cows. Dairy cows were found on nearly every farm. All the milking was done by hand. While some farmers made cheese on their own farms, there were also nearby cheese factories where farmers could sell their milk and have a cash income. One can only hope that the cows did not set a hoof on the top of a young lady's foot or toes—"Ouch!"

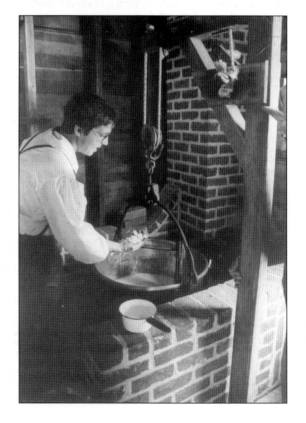

While many farmers would make enough cheese for their own family, they would sell the rest of their milk to a cheese factory. Each forenoon, the milk was delivered, and then the process began. In a huge kettle, the milk was heated over a wood fire and stirred until it was the consistency of cottage cheese. The cheese curds were then put in cheesecloth and pressed to remove the moisture (whey) and then hung to cure. Popular cheeses were brick, Swiss, and Limburger. (Photograph by Steve Hult.)

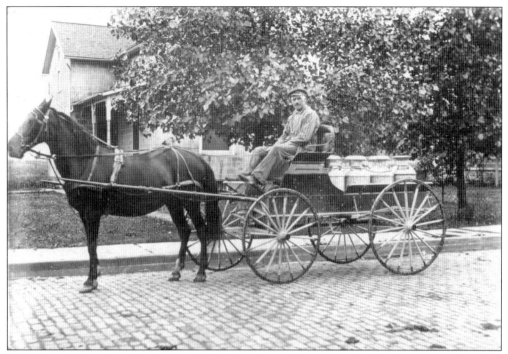

During the first decades of the twentieth century, the milk was loaded on a horse-drawn spring wagon for delivery to the condensery on the northeastern edge of Berne. Many made their daily route on the brick North Jefferson Street.

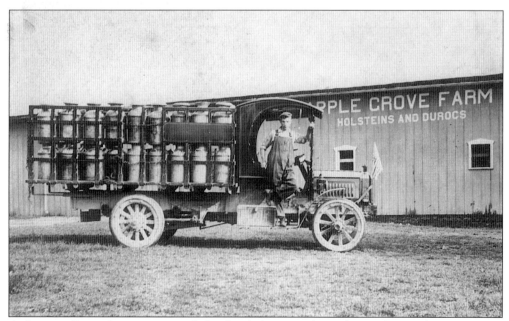

A large milk market was created for local farmers when the Zook Condensery started production here in 1907. Large dairy barns were soon built and milk routes established. The milk haulers had to be physically strong. Full 10-gallon cans weighed at least 100 pounds and had to be loaded and unloaded by the lone driver.

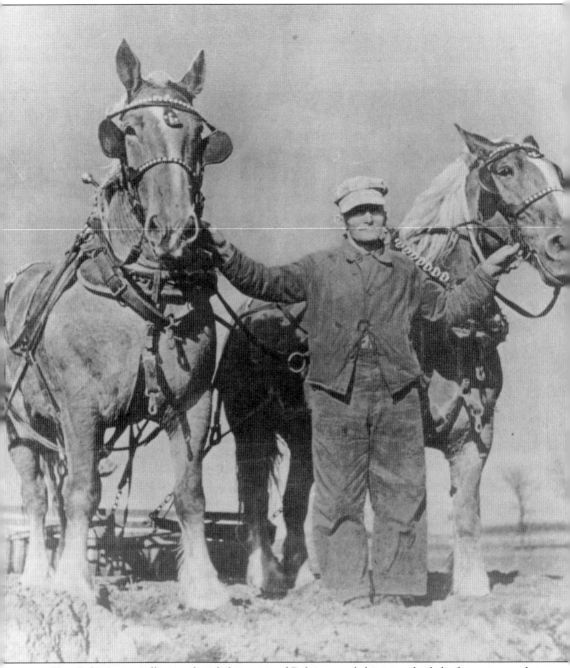

Dan Lehman proudly posed with his team of Belgian work horses, which had won more than their share of pulling contests. After old Maud began to falter, the team was sold. Later, Dick (ears laid back) was paired with Maud's replacement, and the team proceeded to win World Championship honors. Many heavyweight Belgians continue to be spotted in local Amish fields, much to the delight of tourists.

Six

INDUSTRY

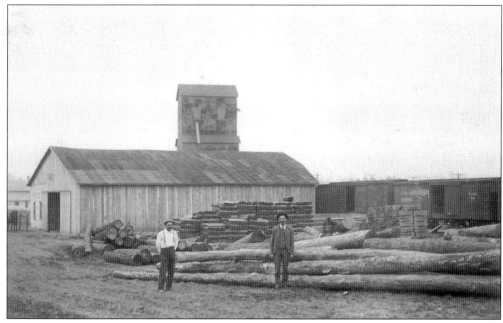

One of the first and chief industries in Berne was the hardwood timber business. Our sawed majestic white oaks were in high demand and were exported to Scotland for whiskey barrels and Canada for shipbuilding. Shown is one of several mill operations, the largest of which produced 12,000 board feet of sawed lumber a day, requiring as many as 20 teams of horses to bring in logs.

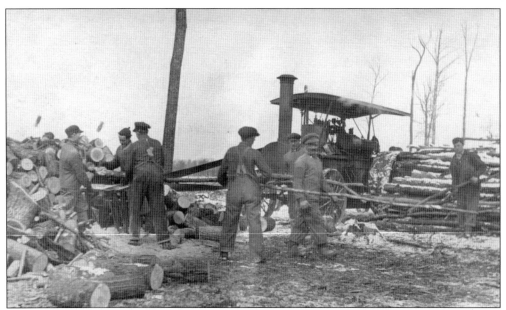

The steam engine operator seems to be looking on as the remaining crew members synchronized their efforts in cutting firewood, which was much in demand by the town's people. Sawn timber ends with dark centers indicated walnut. Indiana is still considered one of the world's largest sources of this wood.

The Berne Hoop Manufacturing Company began in 1891, by A.J. Hawk and his brother Valentine, at the north end of town. The hoop factory was built near the railroad on the present Berne Ready Mix location. In barrel making, wooden hoops were used to hold the wooden staves (sides of barrel) in place. Usually there were two hoops per barrel. In an advertisement, they guaranteed their work to be superior to all others. The hoop factory was dismantled after nine years when the elm timber was depleted.

This mirror with a hand-carved frame is now in the private dining room of Swiss Village Retirement Home. A gift of Miz Lehman, it is a classic in intricate design and precision woodcarving. Rev. and Mrs. Bechtold Ruf came to the United States in 1883 from Switzerland, where he learned the art of carving. His skill was unexcelled, as was his workmanship. Rev. Ruf was pastor of the Reformed Church. He carved many items for the church and the community. (Photograph by Steve Hult.)

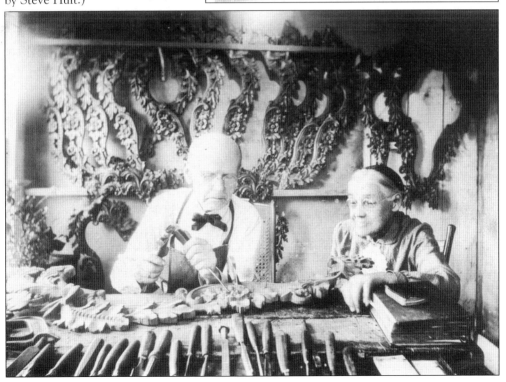

The Dunbar Furniture Company was started in Linn Grove by L.L. Dunbar in April 1919, and moved to Berne in October 1919, because railroad transportation was available. It was the first furniture manufacturer in Berne, and its product became highly regarded throughout the world for over 70 years. Much credit for its initial success has been given to the skilled Swiss wood carvers available for employment.

Berne Furniture was organized in 1925, and has in recent years become one of Berne's main tourist attractions. Of interest to visitors is the adept handcrafting by framers, the deftness of the spring tiers, the precise matching of fabrics by cutters and sewers, and the skills of the upholsterers. The company supports conservation by donating a tree to be planted for every piece of furniture sold.

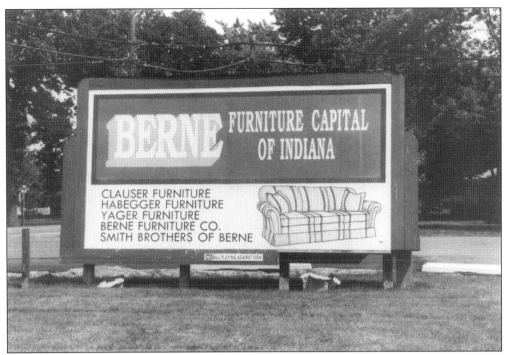

Berne's biggest draw as a shopping center throughout many years has been furniture. Also, tourists and countless other visitors find plant visitations extremely interesting and informative as they view Swiss craftsmen ply their trade. The U.S. 27 highway sign is located on Berne's south side at Lehman Park. (Photograph by Steve Hult.)

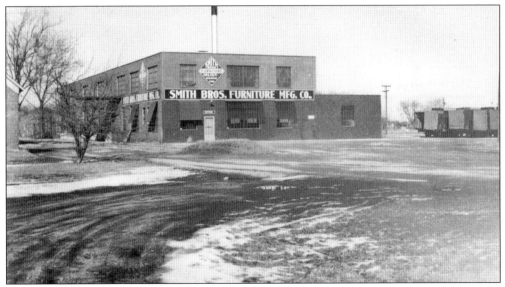

In 1926, Smith Bros. of Berne became Berne's third furniture manufacturer and started by making living room and bedroom chairs. Today it specializes in upholstered living room furniture, which is advertised as "hand made by Swiss craftsmen." The company is widely known and produces nearly 30,000 custom-built upholstered pieces a year, sold in 300 Midwestern furniture retail stores.

The Berne Overall and Shirt Company began in 1915, by E.T. Haecker and his son, Vilas. A two-story brick building was built on the southeast corner of Main and Jefferson Streets. There have been several name changes over the years—Berne Overall Company, Berco, and currently, Berne Apparel.

In 1915, the company was making shirts, overalls, dungarees, smocks, shop coats, and aprons. In the '50s, contacts with leading catalogue retailers prompted the focus on unlined coveralls. Today, coveralls, overalls, jackets, and pants for work wear as well as hunting are the main items manufactured.

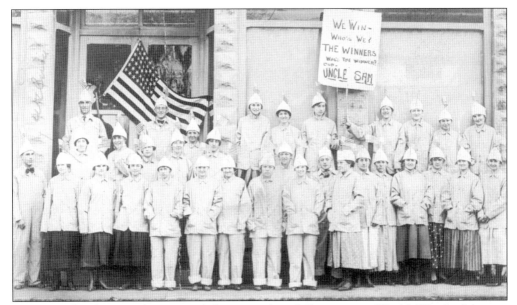

In 1918, after hearing the news of the surrender of Germany in World War I, the town celebrated the restoration of world peace. There was a large parade including school children and business workers marching through town. The employees of the Winner House announced the real winner was our Uncle Sam. Each of the employees made use of an overall pocket as a hat.

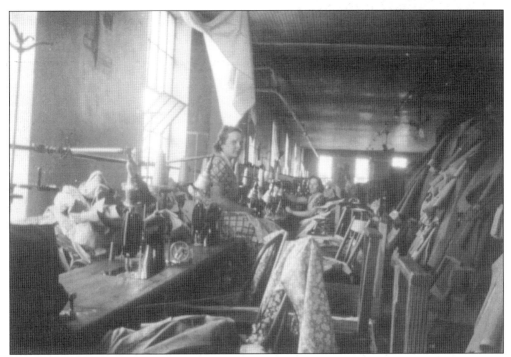

Gladys Neuenschwander takes a quick break from her work in the Berne Manufacturing sewing room in 1940. The plant started as an overall factory in 1904, and succeeded two other smaller garment producers. At one time it was known as "The Winner House." The large cement block building was located on the southeast corner of Main and Lehman Streets.

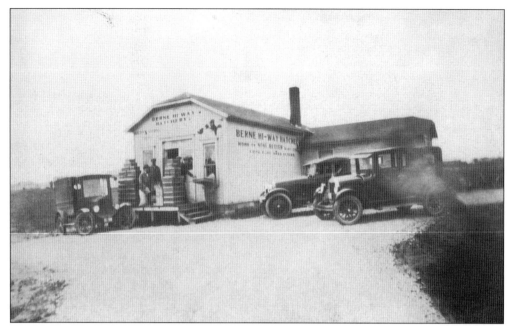

An abundance of grain production here gave rise to a large poultry industry. At first, farmers used eggs to barter for staples, but later large market demands for poultry and eggs led to the establishment of Globe Hatchery in 1917. In 1925, Berne Highway Hatchery was started and is today one of the largest such facilities in Indiana.

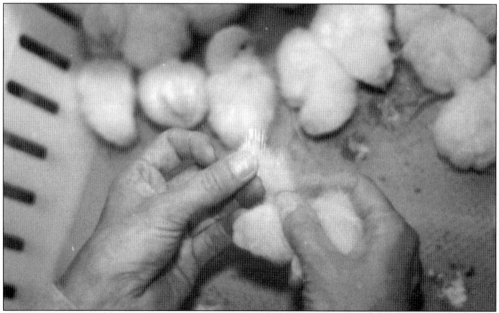

As the poultry industry became more specialized, the sorting of newborn chicks by sex became necessary. As accuracy was imperative, longtime professional training was required. The dilemma was later solved when fast-feathering females, which could be identified just moments after hatching, were genetically developed. Today, the average sexer can sort 2,500 per hour with 99.9 percent accuracy.

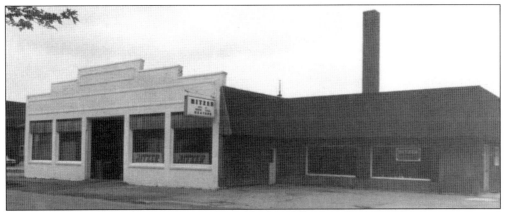

Hitzer Inc., located at 269 East Main Street in Berne, has been manufacturing coal and wood burning stoves since the early 1970s. The name "Hitzer" came from the Swiss term for heater. This family-owned operation is in what once was the Harve Riesen and Walter Schug Main Street Filling Station. The demand for stoves, pumps, fireplaces, and decorative items has spread throughout the United States (including Alaska), Canada, Japan, Poland, and other areas around the globe.

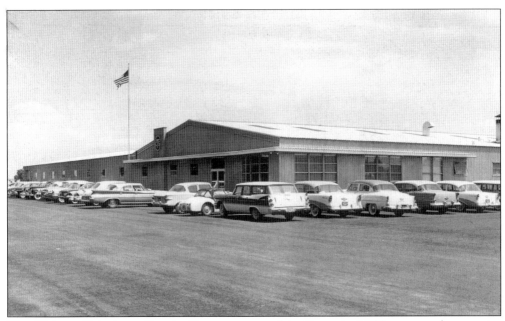

The Chicago Telephone Supply Company opened in Berne in 1958, to manufacture wire wound trimmer resistors. Employment at CTS grew rapidly. The introduction of the 750 Series, initially designed for IBM's 360 computer marked the entry of the company into the electronic data processing industry.

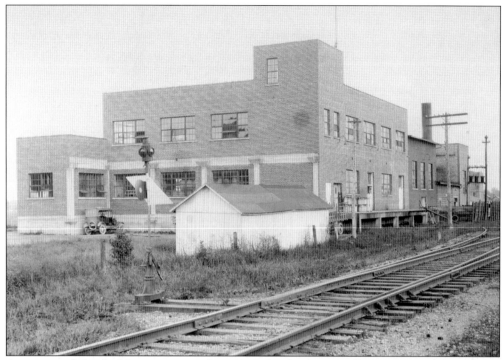

A portion of this building was erected in 1908, by the Swiss Milk Company. It was greatly enlarged eight years later when a large Chicago-based firm purchased the company. Through years of new ownerships and name changes, it has always been referred to locally as "The Condensery." Today, the facility is still standing and used, in part, to process milk.

In 1949, Frank Nussbaum built a plant at the corner of East Buckeye Street and Behring Street in Berne to provide ready mix concrete. Mr. Nussbaum obtained a concrete mixer truck, and with his sons Calvin and Melvin provided this service for 20 years. He then sold it to St. Henry Tile Company, and now, over 50 years later, it is managed by Gene Subler.

Seven
MUSIC

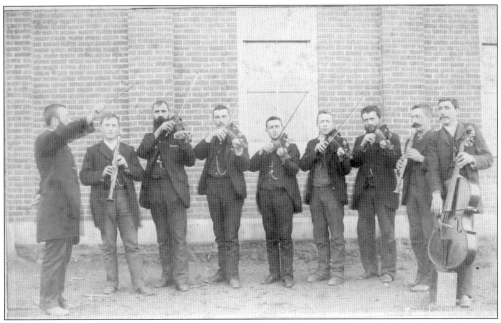

In 1889, Berne's first orchestra was organized by Theophilis Schildknecht shortly after he came from Switzerland. In Switzerland, he was a professor and composer of music. The members of the orchestra were Joel Welty (manager of the Mennonite Book Concern), David C. Neuenschwander (farmer and choir director of the First Mennonite Church), Dr. Ernest Franz (medical doctor), Solomon Moser (farmer), David Bixler (jeweler and optician), John P. Sprunger (shoe cobbler), Fred Eichenberger (head miller of the White Loaf Flouring Mill), and Frank Haecker (manager of the Petroleum Grain & Lumber Co.). These men enjoyed music and thrived on the opportunity to play together.

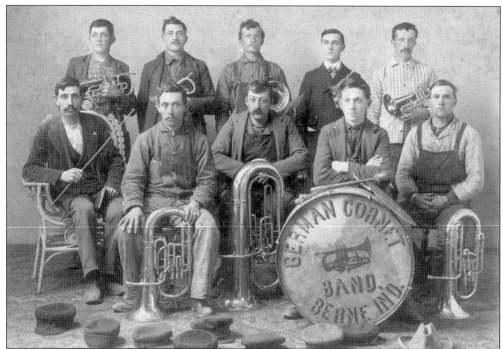

In 1892, the German Cornet Band in Berne was incorporated. They practiced in the evenings over the Baumgartner Bros. Hardware Store under the direction of Eli Luginbill. The band performed at many public gatherings for 16 years. The members, from left to right, were: (front row) Eli Luginbill, Simeon Lehman, Dan Winteregg, drummer unknown, and Menno Neuenschwander; (back row) Eli Baumgartner, Emil Liechty, Noah Fox, Noah Luginbill, and Abe Wahli.

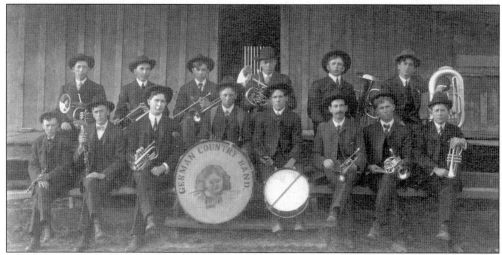

Another band, not of the town, was headquartered at the old cheese factory, northeast of town. The band of young farm boys was led by Abe P. Sprunger and lasted from 1903 to 1909. Some of its members later moved to town and joined the Berne City Band. Pictured from left to right are: (front row) Calvin Sprunger, Abe Sprunger, Dave Stauffer, Reuben Sprunger, Tobias Sprunger, Eli Luginbill, George Sprunger, and Albert Sprunger; (back row) Omer Lehman, Roy Girod, Amos Stauffer, Levi Lehman, John Von Gunten, and Ben Lehman.

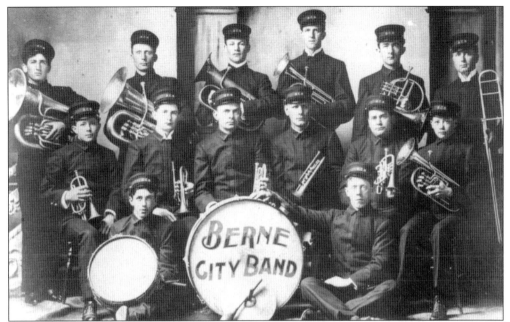

Joe Danner began as conductor in 1912, and contributed music at public gatherings for about 15 years. The band had been begun under the leadership of Louis Gehrig. The demise of this band occurred when several of the members joined the Dunbar Band. Pictured, from left to right, are: (front row) Abe Sprunger, Charles Marks, Emil Aeschliman, and Albert Stauffer; (second row) Eldon Sprunger, Reuben Liechty, Roy O. Girod, Martin W. Baumgartner, Oswald Sprunger, Elmer W. Baumgartner, Bernhart Lehman, Leo Stucky, Rufus A. Stucky, and Calvin Sprunger; (standing row) Amos Stauffer, Milton Gilliom, Omer Lehman, Mr. Thatcher, Director Joe Danner, Chris Hilty, George Braun, Dow Jacobs, and David D. Stauffer.

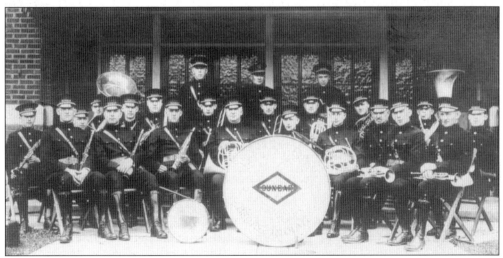

The Dunbar Furniture Manufacturing Company organized a band from their employees in 1923. The company furnished the uniforms and music as well as much encouragement. The band played at all types of occasions for the public. The conductor, Joe Danner, took this band to Indianapolis as one of only 36 bands in the nation to perform at the speedway competition. They were rated at sixth place.

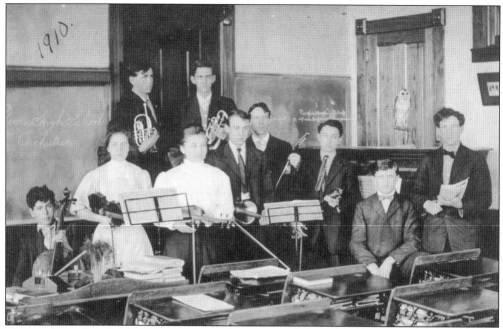

The Berne High School Orchestra of 1910 featured 10 musicians from the sophomore, junior, and senior classes. Pictured left to right are Leslie Baumgartner, Mae (Hocker) Lehman, Enos Lehman, Martha (Baumgartner) Habegger, Orval Smith, Grover Sprunger, unidentified, Ellis Sprunger, Wilbur H. Lehman, and Carl T. Habegger. From the High School Orchestra grew the Symphonic Concert Orchestra. This local Symphonic Orchestra played by invitation at the Palace Theatre in Ft. Wayne winning the praise of the city.

Chris Zuercher brought his family here from Switzerland in 1922, to become part owner and manager of a small accordion factory. After a disastrous fire, with the encouragement and financial help of friends, he built a new, much larger building where he also sold and repaired all kinds of musical instruments. His daughter Irene gave accordion lessons and son Walter organized a much-traveled accordion band.

Miss Helena Liechty organized the Mennonite Ladies Choir in 1912. This select choir consisted only of young, unmarried women who not only had "an excellent voice, but whose daily walk is consistent with their profession." This picture was taken when the choir was on a five-day performance trip to Dayton, Ohio, in 1916. Some of the members pictured are: Rose Lehman (Mrs. M.M. Baumgartner), Martha Gilliom (Mrs. Nathan Sprunger), Inda Sprunger, Martha Burkhalter, Lydia Neuenschwander (Mrs. Herman Lehman), Leona Sprunger (Mrs. Elmer Liechty), and Ernestine Franz. In 1937, the combined Ladies Choir and Men's Chorus presented Stainer's *The Crucifixion*.

The Mennonite Men's Chorus began in 1895. During the 1930s, monthly radio concerts were given. Many invitations came for concerts in both the United States and Canada. In 1959, Paul Mickleson of Word Records came for a recording session with this group—the record was sold out quickly. The accompanist on the left front row was Mrs. Freeman (Mary Kay) Burkhalter, and the director on the right was Dr. Freeman Burkhalter.

The Safety Legion Quartet was sponsored by the Winner House, a local clothing manufacturer. They advertised the Safety Legion work clothes. From the left is Arley Habegger, Emerson Neuenschwander, Carl Luginbill, and C.T. Habegger, plant owner, who would question job applicants about their singing abilities.

The "Winner Chords," a singing group of employees of the Winner House, sang in parts so they made chords. (Much of the children's clothing they produced was of corduroy.) They were in much demand and represented our Swiss community well in their travels.

When Freeman Burkhalter became music director of the Berne School in 1935, he organized a band to supplement the 18-piece orchestra. The music department remained at the Berne Auditorium (now Public Library) when the new high school opened on U.S. 27 in 1939. The 1940 band, like other music groups, walked, ran, or even marched the five blocks to rehearsals. By now, over half the high school students were in one or more musical organizations. The next year, the orchestra won national contest first place honors.

In 1963, the Berne-French Township A Cappella Choir performed at the International Rotary convention in St. Louis to an enthusiastic audience of 11,000. Dr. Freeman Burkhalter and his performers maintained the school's long tradition of quality concert performances and first-place finishes in music contests. The 120 singers represented one-third of the entire high school.

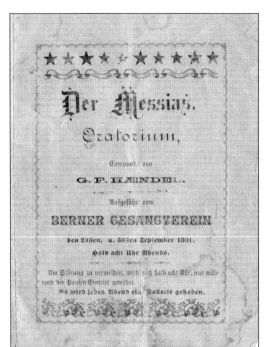

From their homeland in Switzerland, the pioneer settlers of the Berne area brought a deep love of music. Singing was a vital part of their life in the mountains. Their strong religious convictions naturally turned their interest to church music. In 1890, the Mennonite Choral Society was formed with a choir of 48 members. The first rendition of the *Messiah* was given in 1891, as shown on the program cover. The singing was in German, and a tuning fork was used to obtain the pitch. Although the large sanctuary seats 2,000 people, there were many years when standing room was at premium, so beginning in 1950, the *Messiah* was presented in two performances, the first Saturday and Sunday of December.

The Chancel Choir of the First Mennonite Church, under the direction of Dr. Freeman Burkhalter with pianist Mrs. Sherman (Becky) Stucky, was prepared for leading the congregation in worship through music. This choir became the core group of the Mennonite Choral Society, which has presented oratorios each year.

In the early 1900s, the cantatas and oratorios were sung in English. Soon, instrumental accompaniment was included. A spring oratorio is given the first Sunday in May. There have been six times that orchestras have assisted in the presentations. The three-manual church organ has 2,281 pipes that vary in diameter from the size of a pencil to 15 inches. The length of the pipes varies from 6 inches to 16 feet.

At family reunions, it was customary to have a program with music as the central core—vocal or instrumental selections or both. Whether it was at a home or in the park, the Swiss love of music ran a close third to fellowship of family and excellent food. (Photograph by Berne Studio.)

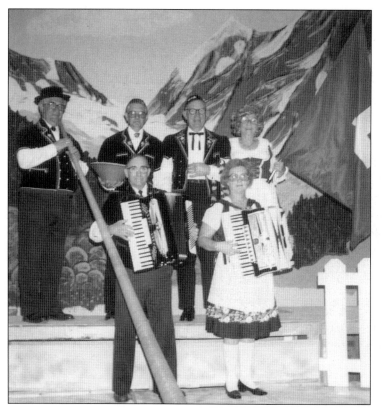

In more recent years, the Folklores became Berne's goodwill ambassadors carrying on the tradition of music brought to Berne by the early Swiss immigrants. From 1978 to 1992, they traveled widely including such places as our governor's mansion. Included in their repertoire were accordion playing, alphorn blowing, yodeling, folk dancing, bell ringing, music, and comedy. In front are Walter Zuercher and Irene Sprunger, and in back are Sherm Stucky, Clyde Sprunger, Delbert Sprunger, and Becky Stucky.

Eight

SOCIAL LIFE

This community has well remembered the instruction of Leviticus 19:32—"Rise in the presence of the aged, show respect for the elderly and revere your God. I am the Lord." Swiss Village Retirement Community offers a full range of needed care services and provides a host of activities for its 331 residents. The center began in 1968, and has continued to expand its facilities and services. There are many ways for all ages to share activities and interact with others in many community settings.

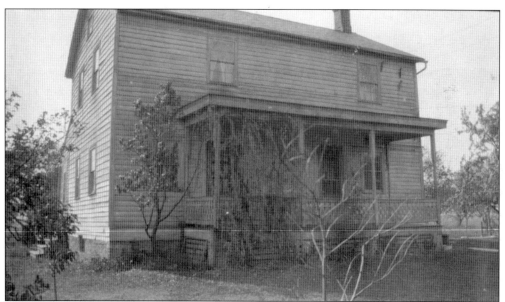

Known as the "Luginbill House," this home has been restored and is located on the 22-acre grounds of the Swiss Heritage Village and Museum in Berne at 1200 Swiss Way. The facility has a number of buildings, along with appropriate artifacts, which portray the local Swiss culture. The time frame depicted is 1838–1900.

The construction of a typical "half-timber" building had originated in Europe, where wood was scarce. The Swiss immigrants brought their construction skills and their frugality with them. The hand-hewn beams were securely placed, and then mud and straw mixed into "wattle" was used to fill the areas between the beams. This also provided some insulation in the wall. (Photograph by Steve Hult.)

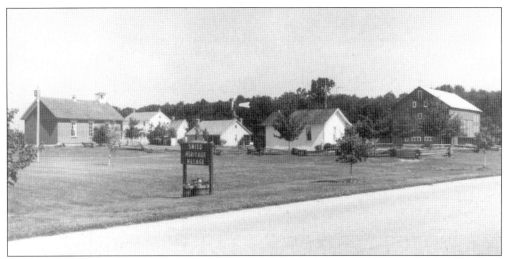

The Swiss Heritage Village and Museum is the largest outdoor museum in northeastern Indiana, now covering over 22 acres. People visit the grounds and restored buildings furnished in the time period of the late nineteenth century. It is a visual reminder of how the Swiss settlers lived in this area more than a century ago. A personally-guided tour is available to the visitor for general admission price. At the northern edge of the property is the Swiss Heritage Woods. Many of the trees and bushes are identified. It makes a pleasant stroll and an enjoyable time of relaxation. (Photograph by Steve Hult.)

Swiss Heritage Days is an early-September event that depicts pioneer times. On the grounds of the Swiss Heritage Village, school children try to split rails and work on other chores that were common to the early settlers. This is an annual educational event.

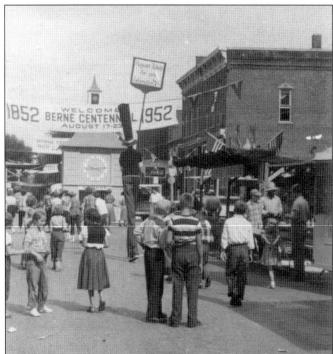

Those who attended the 1952 Centennial celebration 50 years ago clearly remember viewing the information booth and towering "Uncle Sam" who, undoubtedly, had the best view. The booth was a replica of the famous Clock Tower in Bern, Switzerland, and was located in the center of the Main-Jefferson Street intersection.

During Berne's Centennial celebration in 1952, the Beard Contest for the Brothers of the Brush provided a lot of entertainment. The climax was the judging of the best beards in various divisions such as fullest beard, reddest beard, longest beard, and youngest man with a beard. The winners are shown here on the pageant stage, and from left to right are: Milo Habegger, Paul Gehman, Ira Gerber, unidentified, Grover "Jiggs" Moser Jr., Howard Nussbaum, Jerome Yager, Edward Neuenschwander, unidentified, Eli Sprunger, and Eventt Lehman.

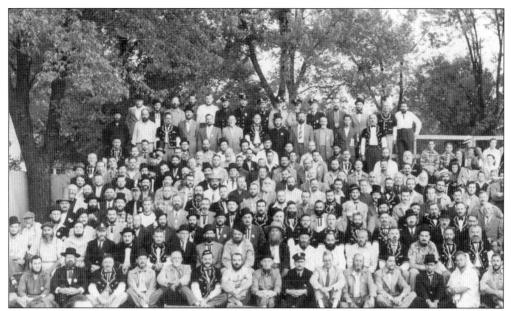

The bearded celebrants pose for a picture as a memento of the 1952 Centennial celebration. At that time when long whiskers were passé, the festive community mandated their growth to commemorate pioneer times. Those who balked were ceremoniously locked up in the old jail cell and publicly ridiculed pending compliance. Those who still refused were heavily fined, with the proceeds helping to defray festival expenses.

The sign carried for all to see by Uncle Sam was a reminder to purchase a ticket for the pageant. The Centennial Pageant, "Time to Remember," included a cast of over 250 people. Many of the hardships, handicaps, joys, and sorrows under which our forefathers struggled to make this country what it became were colorfully re-enacted on the stage in this pageant. Some of the scenes were typical events, and everyone enjoyed the true-to-life scenes of: "An Early Settler's Home, Good Neighbors, Going to Church, The First School, Apple Schnitzing, Our German Band, The First Orchestra Rehearsals, The Saloon Fight, New Year's Eve, and The Family Portrait."

Amishville, a popular tourist attraction, is some 3 miles south of Berne. The 135-acre farm museum opened in 1968 to portray the Swiss-Amish culture, of which avidly interested "outsiders" knew very little. Soon the facility received wide publicity in such newspapers as the *New York Times* and the *Chicago Tribune*. After an ABC Television documentary was aired, visitors poured in by the thousands. In addition to tours and food, the facility offers camping and picnic grounds.

© PENROD/HIAWATHA ® Co. Berrien Center, Michigan 49102

The old spic-and-span house tells much. The bed pot and cupboard dry sink certainly indicates no indoor plumbing. But the food was great. Creamy sweet butter was produced from the regularly used "stomping" churn. Crocks were used to preserve a variety of foods such as sauerkraut and fried-down pork, which was preserved by sealing them with hot lard. Interior scenes are from the homestead at Amishville. (Photographs by Steve Hult.)

Shown is Poplar Drive-In before it was obliterated in 1965 by the big tornado. But in a week it was back in business. The Doyle and Lamar Wintereggs (owners) quickly salvaged debris and, with a few new parts, built a "shack" which they hooked up to the plumbing of LaMar's house trailer, which was also gone with the wind. Started in 1955 on U.S. 27 North, Poplar remained popular for some 30 years.

When the Coffee Shop is mentioned, the first response is usually, "Plug" (Paul Herman) made the best hamburgers. Using fresh hamburger scooped with an ice cream scoop, assuring consistent size, he then smashed them with a plate. With the school across the street, lunchtime was standing-room-only in the tiny place. After athletic practices and games, young and old alike enjoyed the food and the fun to be had there. "Plug" was also known as a prankster. A quarter was placed in the middle of the floor with a clear coating covering it. Needless to say, quite a number of people tried to pick up that quarter.

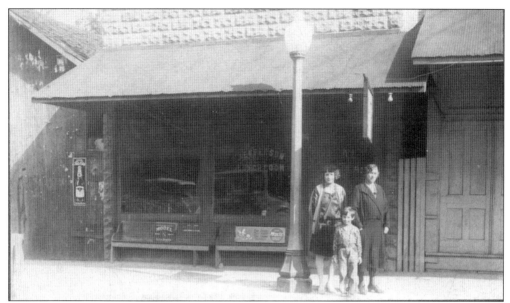

The Jefferson Lunch Room was located at 159 North Jefferson Street. It was opened in the late 1920s, and in the mid-1930s, Otto Kiefer sold the establishment to Charles Brown. They specialized in meals and lunches. They also carried ice cream and candy. There were other businesses in the same building.

This full-service downtown restaurant is the Palmer House after its remodeling in 1961. The large neon sign was to direct out-of-towners to its famous smorgasbord. The building, constructed in 1893, held various and sundry shops in the early years but since has housed restaurants. First it was Blue Creek Dairy, then Ghandi's Grill, and from 1942, the Palmer House after Palmer Liechty bought it. When Palmer left for World War II, the Leslie and Alma Stuckey family members took over. Then owner Gaylord Stuckey, Berne's mayor in 1976, promoted the Swiss architectural theme, and the Palmer House got its present Swiss façade to set an example for Berne's business community.

The White Cottage was originally a Tastee Freeze ice cream stand with two outside walk-up windows. After a few changes of ownership, Blaine and Phyllis Fulton purchased the business from Max and Virginia Sprunger. (Max Sprunger's father was "Ice Cream Mike" Sprunger.) Max commented to the Fultons that he always wanted a little white cottage by the side of the road, and thus the name.

Parkway Restaurant was built in 1948 by Harmon Bagley. Originally, it was a complete transportation center featuring two brick buildings—one on each side of Parkway Street. The north building was a two-story truckers' motel. The present Parkway Restaurant on the south also featured a gasoline service station, and to the south of that, an airplane landing strip. The picture shows the restaurant in 1975. It has since been remodeled with a Swiss motif and is now operated by Mr. and Mrs. Lee Sprunger.

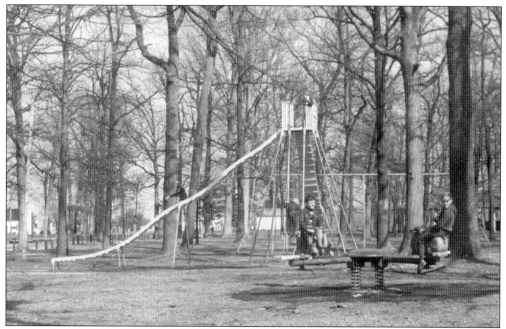

It was known as the "high tower," a two-slide contraption that was for the "big" kids playing in Lehman Park. But the little kids who wanted to be big kids were often hurt, especially after the big kids waxed the slides. So the bottom three rungs of the ladder were taken off, but they still found a way to scale the tower. Finally in 1977, for safety's sake, the contraption was removed. The question remains, "When was it installed?" The old-timers say it was always there.

After the Jaycees sparked the idea in 1962, the Berne Recreation Facilities, Inc., a non-profit group, was organized in August to build a swimming pool. The community responded quickly. Jerome Yager and Clovis Oberli donated land; industry and business offered their resources; service clubs and other organizations gave money; and guidelines for cash contributions from families were set at $100. Committee members painted, landscaped, and performed menial tasks. Ground breaking was in April 1963, and the pool was opened two months later. The fully-paid facility was donated to the City of Berne as part of the 14-acre Lehman Park complex.

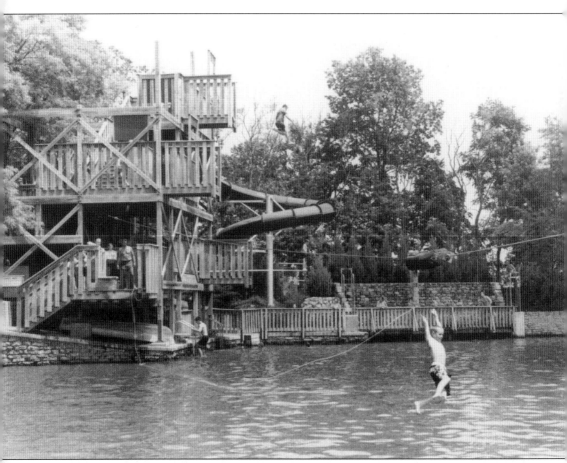

The sand quarry began in 1908, and ran out of sand in 1920. The old abandoned quarry, now filled with water by natural springs at the bottom, was an inconspicuous jewel in a pristine setting. Far off the traveled road, an occasional fisherman or a few youngsters wanting to take a dip may have visited it on lazy summer days. Also, the Egli Mennonite Church found the clear water and shallow west bank as ideal for baptismal services. Then about 80 years ago, the Biberstein farm was purchased by an investor, and the "Sand Pit," as it was called, was opened for public swimming. Most kids from Berne with season tickets would hitchhike the 3 miles west and then walk the long lane to the pond. As time went on, the old swimming hole became "Pine Lake," and by steady development is, today, the finest water recreation spot for miles around. This is a favorite family resort for the community. (Photograph by Steve Hult.)

INDEX